W9-DCL-154

Yosemite and the High Sierra

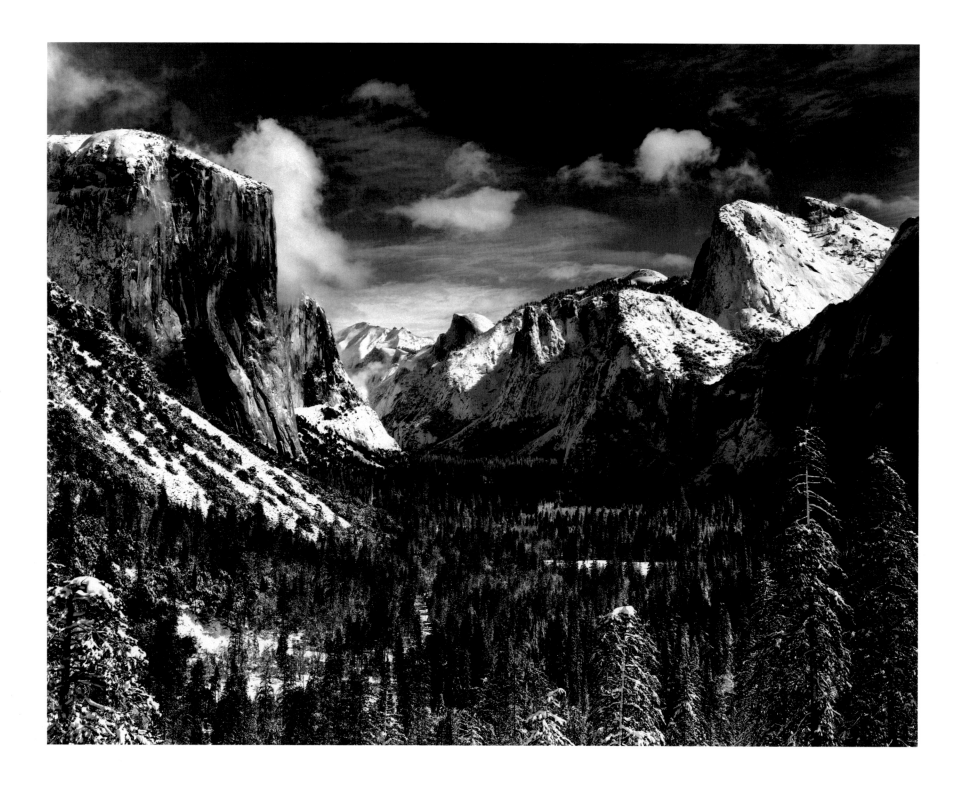

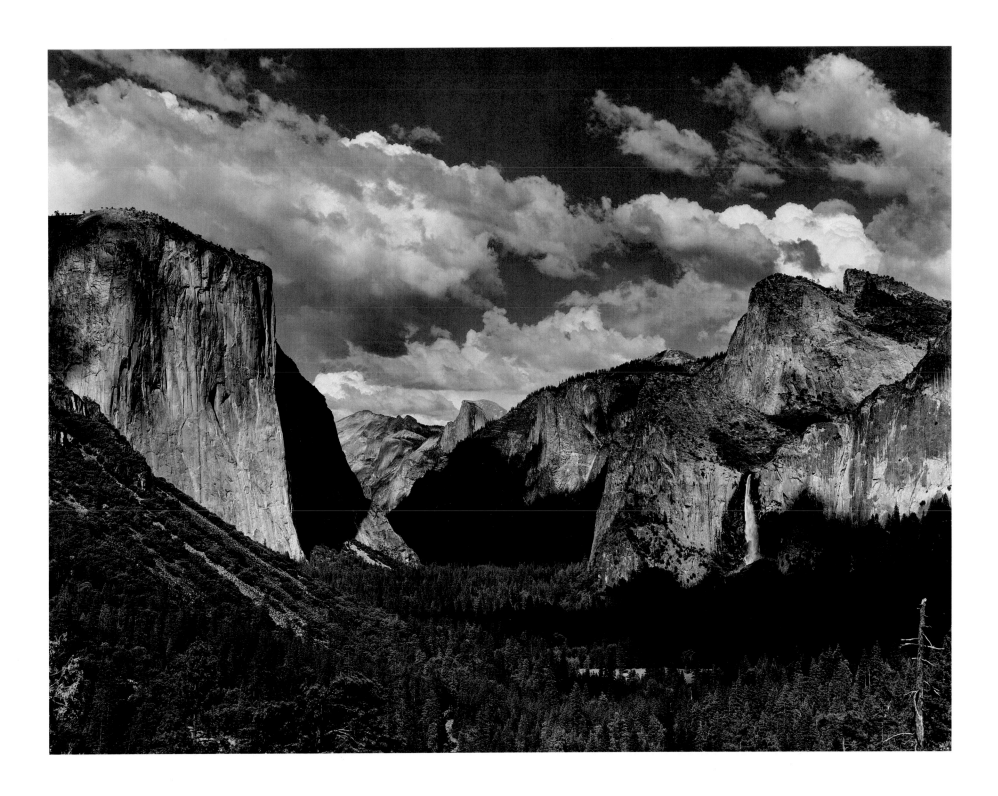

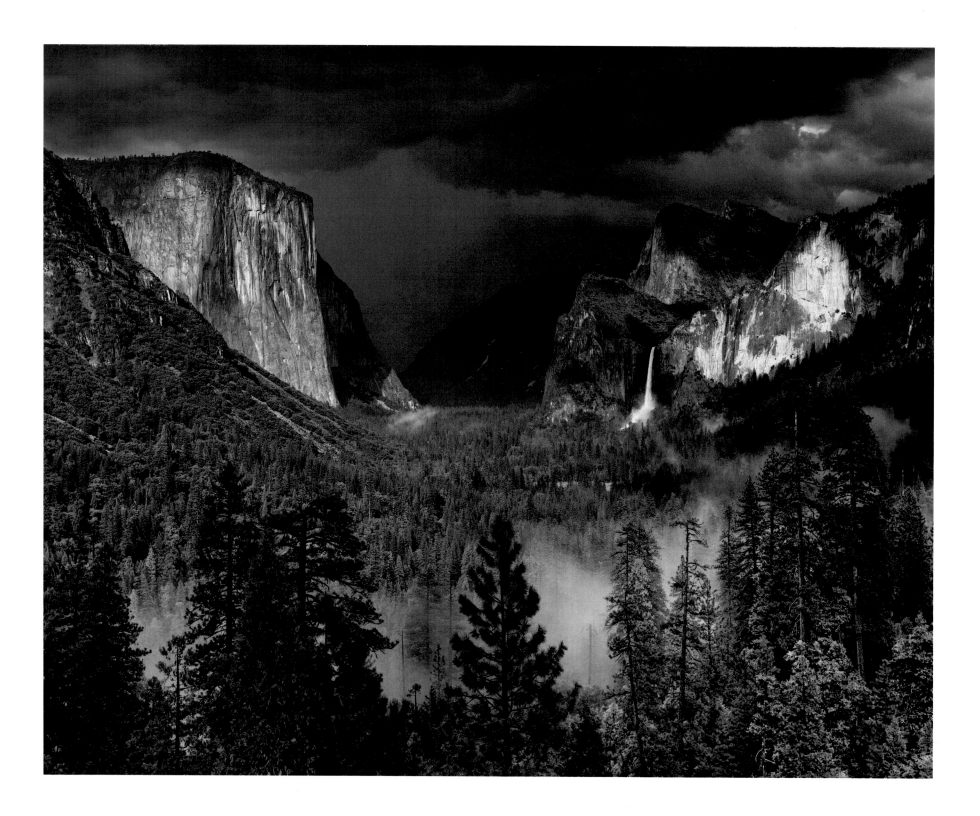

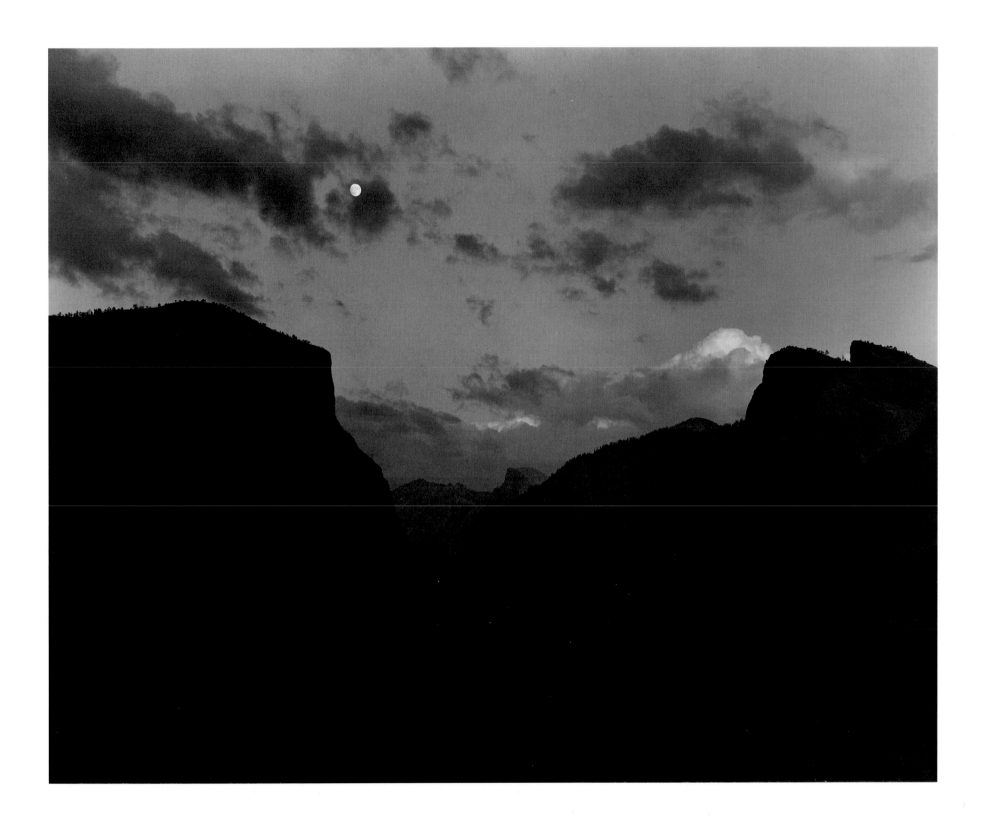

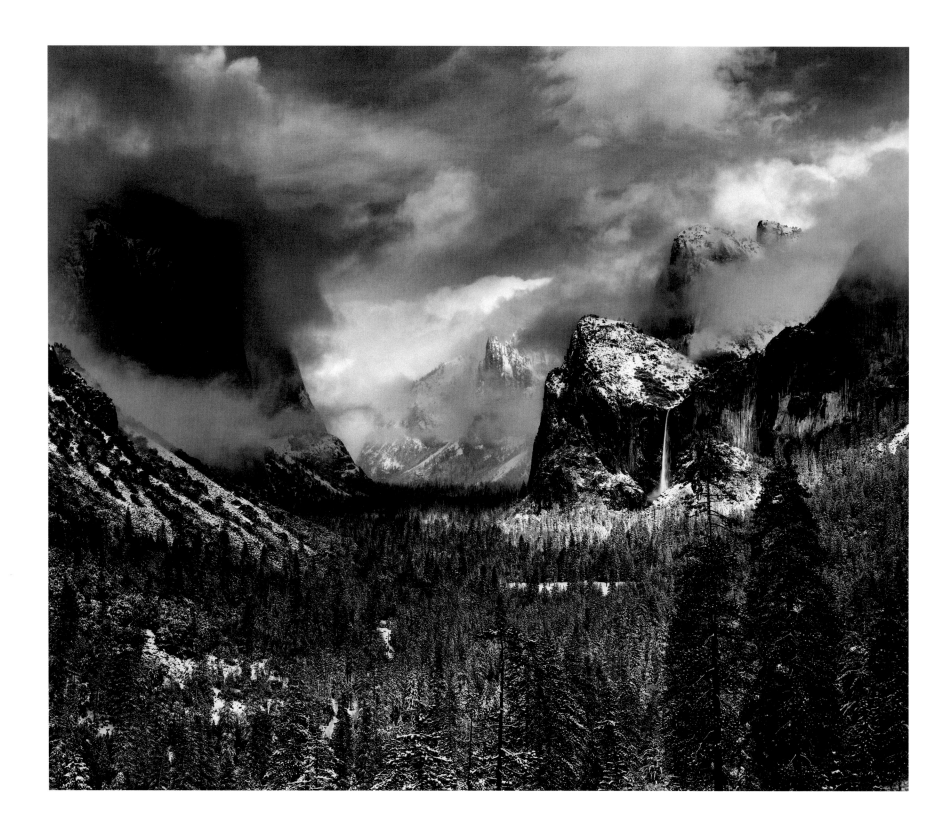

Yosemite and the High Sierra
ANSEL ADAMS

Edited by Andrea G. Stillman
Introduction by John Szarkowski

LITTLE, BROWN AND COMPANY
New York Boston London

In 1976, Ansel Adams selected Little, Brown and Company as the sole authorized publisher of his books, calendars, and posters. At the same time, he established The Ansel Adams Publishing Rights Trust in order to ensure the continuity and quality of his legacy—both artistic and environmental.

As Ansel Adams himself wrote: "Perhaps the most important characteristic of my work is what may be called print quality. It is very important that the reproductions be as good as you can possibly get them." The authorized books, calendars, and posters published by Little, Brown have been rigorously supervised by the Trust to make certain that Adams' exacting standards of quality are maintained.

Only such works published by Little, Brown and Company can be considered authentic representations of the genius of Ansel Adams.

Little, Brown and Company
Hachette Book Group USA
237 Park Avenue, New York, NY 10017
Visit our Web site at www.HachetteBookGroupUSA.com

First Edition
Sixth Printing, 2008

Little, Brown and Company is a division of Hachette Book Group USA, Inc.
The Little, Brown name and logo are trademarks of Hachette Book Group USA, Inc.

Library of Congress Cataloging-in-Publication Data
Adams, Ansel, 1902–1984.
 Yosemite and the High Sierra / Ansel Adams ; edited by Andrea G.
Stillman ; introduction by John Szarkowski.—1st ed.
 p. cm.
 Includes bibliographical references.
 ISBN 978-0-8212-2134-1
 1. Landscape photography—California—Yosemite National Park.
2. Nature photography—California—Yosemite National Park.
3. Yosemite National Park (Calif.)—Pictorial works. 4. Adams,
Ansel, 1902–1984. I. Stillman, Andrea Gray. II. Title.
TR660.5.A3 1994
779'.3679447'092—dc20 94-8522

PRINTED IN ITALY

Photographs on pages 2 through 7:
1. Yosemite Valley, Winter, Yosemite National Park, c. 1940
2. Yosemite Valley, Summer, Yosemite National Park, c. 1935
3. Yosemite Valley, Thunderstorm, Yosemite National Park, 1949
4. Yosemite Valley, Moonrise, Yosemite National Park, 1944
5. Clearing Winter Storm, Yosemite National Park, 1944

Contents

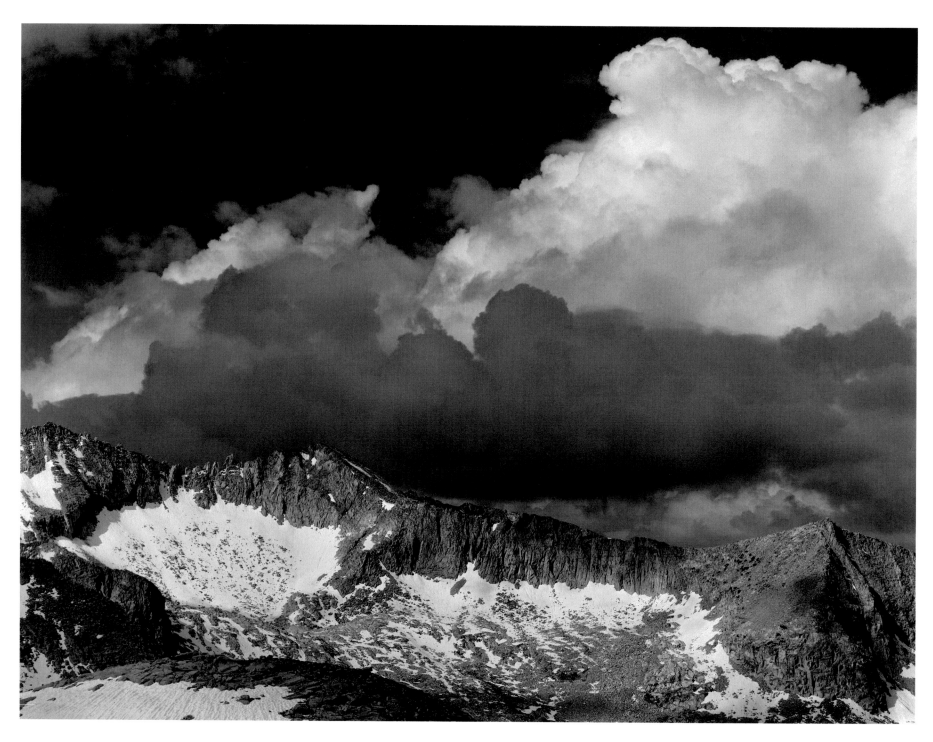

6. Clouds, Kings River Divide, Sierra Nevada, c. 1932

Ansel Adams and the Sierra Nevada

JOHN SZARKOWSKI

Yosemite Valley and the High Sierra are contiguous, but they are not the same place. They might almost be thought of as the two poles of the ancient landscape idea, with Yosemite representing Eden, the humane and fertile place, and the high mountains hell (or, rather, purgatory—an interjacent place). From the height of the land one can look westward, toward the land of milk and honey, or eastward, into hell—down into the mountains' great rain shadow and the dead and frightening desert.

The geologist Clarence King had looked down into Yosemite, in the full spring of 1864, "upon emerald freshness of green, upon arrowy rush of swollen river, and here and there, along pearly cliffs, as from the clouds, tumbles white, silver dust of cataracts. The voice of full, soft winds swells up over rustling leaves, and, pulsating, throbs like the beating of far-off surf. All stern sublimity, all geological terribleness, are veiled away behind magic curtains of cloud-shadow and broken light."[1] Three years earlier, Mark Twain had crossed the desert that lay over the mountains and described what it was like there: "Imagine a vast, waveless ocean stricken and dead and turned to ashes. . . . There is not a sound—not a sigh—not a whisper—not a buzz, or a whir of wings, or distant pipe of bird—not even a sob from the lost souls that doubtless people that dead air."[2]

Those of us who make little trips into the vestigial remnants of half-wild land, carrying freeze-dried food and space-age camping gear, tend to believe that we are ready to live in a symbiotic relationship with the earth. We also assume, with little evidence, that the earth is ready to live in a symbiotic relationship with us. This optimistic view has tended to make us reject the traditional opinion that the relationship between man and the rest of nature is typically adversarial, and adopt instead the belief that the earth is essentially friendly. This is a novel and largely untested idea; its brief history might be studied best in the

record laid down in the landscape pictures made by painters and, since the middle of the past century, photographers.

So large an ambition is clearly beyond the scope of this brief essay, but it might be possible to suggest here in rough outline how the work of one exemplary landscape artist relates to this large philosophical issue.

Ansel Adams' work embodies both the quality evoked by the passage from King and that evoked by the passage from Twain. The difference does not reside in the putative character of the nominal subject, but in the pith and marrow of the picture itself. The great *Clearing Winter Storm* (Plate 5) is, in spite of its title, finally a friendly picture; we seem to watch the splendid event from a comfortable sanctuary, perhaps a sanatorium that we could not be expected to leave. In contrast, *Frozen Lake and Cliffs* (Plate 65) gives us no dramatic spectacle, but simple terror. Under the thin, cold light of the starvation moon we almost hear the chattering of the windigo's teeth, as he stares at the heels of his victim.

In 1927 Ansel Adams, age twenty-five, wrestled with the problem of whether he should continue to pursue a career as a concert pianist, or devote all of his creative energies to photography and declare himself a professional. He had no useful model for the second option—he knew no one who had even tried to be a commercially successful photographer and an artist as well, and it would have been hard to find one in the neighborhood. There was one professional photographer in San Francisco who had produced a truly heroic body of work: the great Carleton Watkins. Watkins, who had first photographed Yosemite in 1861, did not die (in penury) until 1916, the same year that Adams first visited the great park and attacked it with his box brownie. It is perhaps fortunate that Adams was not familiar with Watkins' example. Had he known the odds against a photographer succeeding both as an artist and a professional he might have chosen the sensible course and continued to pursue the role of concert pianist, where success seems more common.

The goal that Adams was contemplating offered bleak prospects anywhere; but in New York there were at least, as exemplars, the four Big S's—Stieglitz, Steichen, Sheeler, and Strand—all of whom were certainly artists, and all of whom but Stieglitz could claim to be professionals, at least part-time. In California, Edward Weston, Dorothea Lange, and Imogen Cunningham, none of whom Adams knew, kept the wolf provisionally at bay as old-fashioned portrait photographers—old-fashioned in the sense

that they worked for the sitter rather than the magazines or the movie studios or the public relations experts—but the work that they got paid for was generally not very interesting except to the sitter, and they did not get paid enough for it.

Nevertheless, Adams chose photography. Or perhaps it was not photography but Yosemite he chose. While the issue was still in doubt he wrote Virginia Best, his future wife, an unusually revealing letter: "Music is wonderful—but the musical world is the *bunk!* So much petty doing—so much pose and insincerity and distorted values. . . . It seems very clear to me now that unless I get more of the outdoors, I will blow up. I find myself looking back on the Golden Days in Yosemite with supreme envy. I think I came closer to really living then than at any other time in my life, because I was closer to elemental things—was not so introspective, so damned sensitive, so infernally discriminative."[3]

When John Constable was forty-five he wrote to a friend, "I should paint my own places best; painting is with me but another word for feeling, and I associate 'my careless boyhood' with all that lies on the banks of the Stour; those scenes made me a painter. . . ."[4] There is perhaps no persuasive reason why we should not take Constable at his word. No reason, that is, not to believe that in quite a literal way he became a painter so that he could record—*reproduce*, in a less ephemeral form—the visceral experience of his own physical world. It does not seem to us now an odd ambition for an artist who believed that nature was art's model. We are of course more likely to believe that art is art's model, and in this belief we are probably correct, at least statistically (as were Constable's colleagues, who, perhaps from the suspicion that he revered nature even more than art, waited until Constable was fifty-four before electing the great painter to membership in the Royal Academy).

In defense of the Academy, it should be noted that its members believed that landscape painting (plain landscape painting, without the inclusion of historical events or ancient myths) was a genre profoundly and inherently inferior to history painting, since the former was incapable of dealing with issues of moral moment. If this was the case, a history painting not quite of the first rank was potentially a nobler thing than the most wonderful of pure landscapes.

As the nineteenth century advanced, pure landscape painting came to be recognized as a genre capable of supporting artistic ambitions as high as any other, while history painting died unmourned, both developments driven by causes which have not been adequately explained. It is not altogether clear

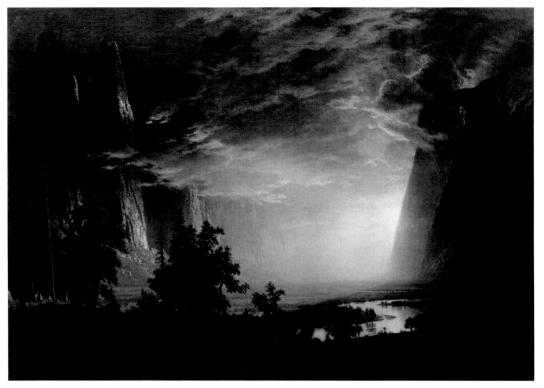

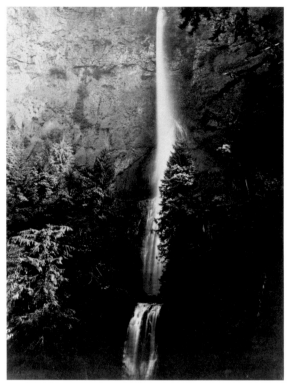

1. Albert Bierstadt. *Sunset in the Yosemite Valley*, 1868. Oil on canvas, 35^1/$_2$ × 51^1/$_2$ inches (90.2 × 130.8 cm.). Courtesy of the Haggin Collection, The Haggin Museum, Stockton, California.

2. Carleton Watkins. *Multnomah Falls Cascade, Columbia River*, 1867. Albumen silver print from glass negative, 15^3/$_4$ × 20^5/$_8$ inches (40 × 52.4 cm.). Courtesy the Gilman Paper Company.

whether landscape painting was elevated or whether painting as a whole had been relieved of its high philosophical responsibilities.

After World War I, however, the status of landscape painting declined again, and by the thirties artists whose work did not seem to engage the social and political crises of the time were at least a little suspect. In these years even Matisse was felt by many to be a political problem and described by them as a minor master—a decorator of genius—because of his failure to address social issues and perhaps more generally because his work eschewed *Sturm und Drang* as an artistic strategy.[5]

In the case of photography the historical situation was somewhat different; the question of an artistic hierarchy of subject types hardly arose, since the artistic status of photography itself was only periodically an issue for discussion. During the heady experiment of photography's first two decades there

had been much talk about photography as an art (meaning a fine art), but by the 1860s most of those who called themselves artists had retired from the field, leaving it to those who called themselves explorers, scientists, reporters, record makers, illustrators, or simply photographers. It was not until the end of the century that a broad public began to hear increasingly shrill claims made for photography's artistic status. By that time landscape was unquestioned as a major genre in painting, so it was naturally also accepted as an important subject for artistically ambitious photographers. In the course of a generation, however, photography's Fine Arts movement, which started so bravely and with such high hopes, had transformed itself into an immense network of hobbyists, who produced progressively dim copies of the old successes, and awarded each other prizes. By the 1930s the bankruptcy of the Pictorialist idea, in combination with a worldwide depression and epidemic political chaos, had persuaded most viewers that it was the business of serious photography to deal with the clear and present crises that confronted society. Making landscape photographs seemed worse than irrelevant; it seemed callous. In 1931 the critic Kenneth Rexroth apparently wrote to Edward Weston—more in sorrow than in anger, he might have said—to say that although there was no question about his talent, Weston couldn't expect to achieve anything significant unless he got serious about the class struggle.[6] In fact, a selective search of Weston's files would have turned up a few good pictures that might be pressed into service as evidence of his political awareness. Adams made a number of conscious attempts to photograph the social scene, but he was not especially good at it.[7] He did his best work in the High Sierra, one of the most otherworldly of landscapes, a place to which the sound of the world's agonies did not carry.

Adams was not the first to work there, but it had been a long time since a photographer of high talent had applied himself to that subject. Watkins and Weed and Muybridge, the great Yosemite photographers of the heroic wet-plate period, had done their work there more than half a century before Adams started. During the last third of the nineteenth century they and others made genuinely original landscape pictures in the American West. What was most radical about these pictures was their emptiness of any human reference. Even the great crowd-pleasing landscape painter Albert Bierstadt often could not, in the high mountains, find a way to connect the awesome scene with the reassuring idea of civilization, but he could at least bathe the scene in the light of conventional theatricality (Figure 1). To photographers, who were stuck with the plain facts and the light that was there, the problem was even more severe, and the best pictures of the best photographers constitute an artistic solution which is

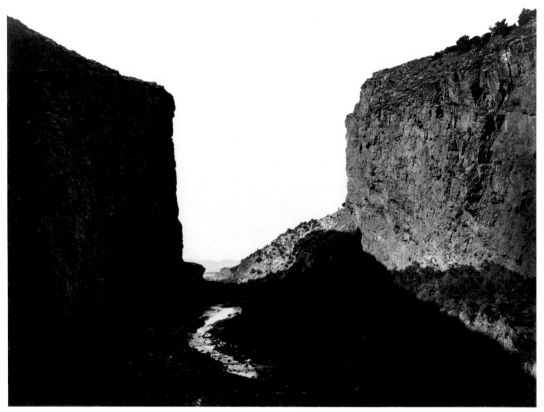

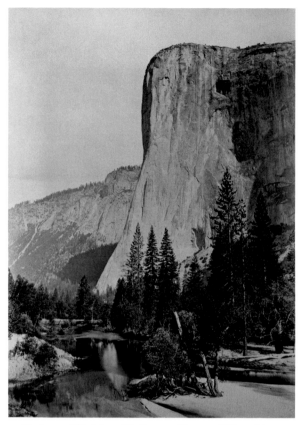

3. Timothy H. O'Sullivan. *Vermillion Creek Canyon*, 1872. The Library of Congress, Washington, D.C.

4. Carleton Watkins. *El Capitan, Yosemite Valley*, 1880. Albumen print, 21 3/16 × 15 1/4 inches (54 × 39 cm.). Collection of the J. Paul Getty Museum, Malibu, California.

almost as fiercely desolate, as free of sentiment, as abstracted from human priorities, as the land they photographed (Figures 2 and 3).

It is not clear what Adams felt he might add to the achievement of these pioneers; it is not even clear how much he knew of their work. Surely he did not in the beginning know the landscapes of Timothy O'Sullivan; it seems that no one did. Adams discovered him ten years later and sent an album of his photographs, made in the early 1870s, to Beaumont Newhall at the Museum of Modern Art. In his letter he said, "A few of the photographs are extraordinary—as fine as anything I have ever seen."[8]

Whether or not Adams had ever known the work of Watkins and O'Sullivan, his work would have been different from theirs since he was two full generations younger than they. Style, in its more

important meanings, is not the invention of individuals, but the expression of the shared assumptions of a time. This is why a half-sophisticated art lover can look at an unfamiliar painting in a museum in an unfamiliar city, and guess with some confidence that the picture is from the north of Europe, let us say, in the late fifteenth century, without having the ghost of a notion as to what painter may have made it. It is easy for us now to see that the paintings of a particular place and time have much in common, even though the people who lived there then could doubtless see more clearly what were to them immense differences. It is the same with photography, and by now Adams' work has been with us long enough to allow us to recognize—even though his pictures do not often include funny hats or exotic automobiles—that it is of the same time as the work of his contemporaries.

I have written elsewhere on the thesis that Adams' work, like that of Cartier-Bresson, for example, is devoted to the transient and the ephemeral.[9] I will not repeat that argument here, but will simply call attention to two superb photographs of El Capitan, one made by Carleton Watkins in 1880 and one by Adams almost a century later (Figure 4 and Plate 31). In each case the example is typical of the photographer's characteristic style, and the comparison makes clear the difference in their subjects. One might say that Watkins photographed geology, and Adams the weather. Between the time of Watkins and that of Adams photographers had been given dry film of great speed and panchromatic color response, and these changes defined a new set of pictorial possibilities,[10] but this is perhaps not the whole story. For technical reasons, Watkins could not have made the Adams picture, though Adams could easily have made Watkins'; but perhaps it no longer seemed to the point for Adams to describe a wilderness that looked so unchallengeably stable and permanent.

Of the list of great photographers who reached their majority in the 1920s—Adams, Alvarez-Bravo, Brandt, Brassaï, Cartier-Bresson, and Evans—only Adams made landscape his central preoccupation. Adams is in several other ways the odd man on the list, perhaps most obviously because of his clear discomfort with most of the tenets and attitudes of modernism. The other photographers all have excellent surrealist credentials, except perhaps for Evans, whose favorite modernist hero was James Joyce. Adams, in spite of his close early association with the Museum of Modern Art, had difficulty concealing his distrust of modern painting (unless it was done by a friend, preferably John Marin). Beginning in 1940 Adams spent substantial periods of time at the Museum of Modern Art as the Vice-Chairman of its Department of Photography. David McAlpin, the Trustee Chairman of the new department, had asked

Adams to come as advisor to him and Beaumont Newhall, the curator. Adams was thus in a position to enjoy a privileged view of the young museum's thought processes, but there is little evidence that he paid attention to what transpired outside the bounds of the new department. He was at the museum when René d'Harnoncourt was preparing his historic exhibition *Indian Art of the United States;* the subject must surely have interested Adams, but his voluminous correspondence seems not to record any awareness of the show. It appears, in fact, that Adams, Newhall, and McAlpin looked for guidance and approbation not first to Alfred Barr, the founding director of the museum, but to the aging Alfred Stieglitz, the great photographer and art dealer who presided over two white rooms a block to the east, at 509 Madison, called An American Place (perhaps named that by Stieglitz to contrast it to the Museum of Modern Art). Stieglitz was of course himself a modernist and an early champion of modern painters, but something had gone subtly awry; perhaps too many champions had entered the field. For whatever reasons, Stieglitz found it increasingly difficult to give unambiguous praise to artists outside his small and shrinking circle, and impossible to entertain the notion that an institution—such as the Museum of Modern Art—could deal with affairs of the spirit. Stieglitz's narrowing perspective resulted in a rejection—de facto if not de jure—of most new art, and this may have reinforced Adams' native inclination.

Adams was someone who was happiest on the tops of mountains, and it is not surprising that he did not like to be crowded, physically or morally. When told that he should be traveling another road, he tended to take it personally—and there were many during the thirties and forties who were ready to tell him that.

Some artists who in the thirties had been perhaps a little tardy about abandoning the high wine of surrealism for the plain water of social service became virtual prohibitionists once they had seen the light. One of these, Henri Cartier-Bresson, still seemed, as late as 1952, morally affronted by the notion that a photographer could be so disengaged from social problems as to photograph the natural scene: he said, "Now, in this moment, this crisis, with the world maybe going to pieces—to photograph a *landscape!*"[11]

As we have seen, Cartier-Bresson's view of landscape as a morally inferior genre was not a radical new idea, but one with an ancient and honorable tradition. The argument that a history painter of the second rank might be a greater artist than a landscape painter of the first rank does not seem to me fallacious on its face, nor does it seem to have been defeated in battle; instead the history painters simply lost heart and gradually abandoned the field.

Three years before Cartier-Bresson expressed astonishment that a photographer would photograph a landscape, the Oxford University Press published a slim, unheralded book titled *A Sand County Almanac,* by Aldo Leopold. By now the book has sold 1.3 million copies,[12] and it might in retrospect be thought of as a benchmark indicating the beginning of a new period, during which we have been required to expand both our sense of social conscience and our definition of the crisis, so that both now conspicuously include a concern for the landscape.

Nevertheless, it would be wrong to forgive Adams his antisocial sins of the thirties on the unpersuasive grounds that he was a premature ecologist, who saw farther down the social pike than his fellows; he was in fact an artist, who saw not much farther than his own heart, and who kept photographing unoccupied places because he felt most alive in those places. What Adams did was in fact worse than photograph landscape in a traditional sense (the sense in which Cartier-Bresson understood the word), for the traditional landscape recorded the evidence of man's difficult and often precarious tenancy of the globe—high on the hillsides are the ruins of temples, and in the valleys, shepherds' huts, and the pastures are embroidered with the trails of kine and sheep. The landscapes that Adams photographed, however, contain no suggestion of human habitation; many of the places where he worked best are insistently inhuman, a fact not lost upon those who have found these places compelling. When Clarence King explored the Sierra Nevada in the 1860s he was struck by the desolation of their eastern slope: "Here and there the eye was arrested by a towering crag, or an elevated, rocky mountain group, whose naked sides sank down into the desert, unrelieved by the shade of a solitary tree. The whole aspect of nature was dull in color, and gloomy with an all-pervading silence of death. . . . Water was found at intervals of sixty or seventy miles, and, when reached, was more of an aggravation than a pleasure—bitter, turbid, and scarce; we rode for it all day, and berated it all night, only to leave it at sunrise with a secret fear that we might fare worse next time."[13]

Those who are drawn irresistibly to such places might seem somewhat odd to wholly civilized sorts, and their view should not be dismissed out of hand. Henry James called Clarence King "the most delightful man in the world" but did not discount the possibility that there was a touch of madness in his sanity.[14]

In his old age Ansel Adams was as sane as a milkmaid, but the earlier photographs of him suggest a slightly different person. After the age of fifty or so, as Adams gained a little substance—a little flesh on

his bones, a little fame outside the small world of photography, and eventually a little money in the bank—he began bit by bit to resemble the lovable, trusted, avuncular Adams of his old age. But when he did his best work he more closely resembled our mental image of Cassius, or Savonarola—a tall skinny man with a sharp-pointed chin and deep-set dark eyes and a broken beak of a nose, who might have been mistaken, by those who placed faith in appearances, for some sort of fanatic.

As we approach more closely the quality that is most original and most powerful in Adams' work of the thirties it may come to seem less and less the work of a conservationist or an educator, of a wise and patient leader of men, principled but reasonable (all of which things Adams surely was or later became), but rather the work of a person who we might guess to be of a more solitary, intuitive, nervous bent— perhaps even a quasireligious sort.

In an undated but early fragment he wrote, "I was climbing the long ridge west of Mount Clark. It was one of those mornings when the sunlight is burnished with a keen wind and long feathers of cloud move in a lofty sky. The silver light turned every blade of grass and every particle of sand into a luminous metallic splendor; there was nothing, however small, that did not clash in the bright wind, that did not send arrows of light through the glassy air. I was suddenly arrested in the long crunching path up the ridge by an exceedingly pointed awareness of the *light*. The moment I paused, the full impact of the mood was upon me; I saw more clearly than I have ever seen before or since the minute detail of the grasses, the clusters of sand shifting in the wind, the small flotsam of the forest, the motion of the high clouds streaming above the peaks. There are no words to convey the moods of those moments."[15] Adams' words in fact convey the mood very well, and in addition describe the character of his best pictures from his best years better than anyone else has managed.

I have suggested elsewhere that there is a significant difference between Adams' earlier and later work. The change was both gradual and discontinuous, but it seems to me that its center line might be located in the mid forties. According to their tastes, individual viewers will on average prefer his work before or after that date.[16] In my view, the earlier work was at its best private, lyric, and classical in mood (Plates 63, 65, 73; Figures 5 and 6). The later work is typically public, epic, and declamatory (Plates 5, 7, 70, 72). What caused the change is unknown and probably unknowable. Like other people, artists change, for reasons which may be either obvious or inscrutable; and their work changes, reshaped by forces which may be private and interior or public and cultural. It is vain to think that we might calculate the vectors

that move an artist's work first toward one unknown destination and then in a slightly different direction, but one cannot help but try to understand at least the broad outline of the story. It seems to me at least possible that Adams' future was influenced by the very unusual assignment that he served intermittently between 1940 and 1946.

During the years that produced his important photography Adams continued to be torn between the gregarious and the solitary sides of his character. He loved conviviality and parties and the excitement of city life—for a few days—and then he would race, almost in panic, for a wild space. In 1940 this ambivalence was put to a new order of strain when David McAlpin asked—almost ordered—Adams to report to the Museum of Modern Art as his advisor. McAlpin, who had collected Rembrandt etchings as an undergraduate at Princeton, later fell in love with photography, and in 1936 he bought eight prints from Adams' exhibition at An American Place. He was now being asked to oversee the definition of objectives and strategies for an independent curatorial department of photography in an art museum: something that had not existed before, as far as the principals knew, although Adams had outlined something of the sort in his book *Making a Photograph*.[17]

Adams served this rather odd assignment with energy and passion, but he forewarned McAlpin that he could not serve the conventional fifty-week year. He did of course have obligations in California that could not be ignored, but perhaps he also realized intuitively that it would be better to take New York in small doses. He arrived in New York in mid October 1940, only a month after the museum's trustees had formed the new department, and quickly began work with Beaumont Newhall on the exhibition *Sixty Photographs*. He was, however, back in San Francisco before the exhibition opened on the morning of New Year's Eve.

Adams had been in effect codirector of the exhibition, and he was naturally eager to hear news of its reception. Some forty years later, in his *Autobiography*, he remembered that the exhibition was "an unqualified success,"[18] but it would seem that in this instance his memory failed him. The first reports were positive; McAlpin and the Newhalls both wired good news—Stieglitz had come to see the show and had seemed pleased. Rather than leave well enough alone, however, Adams asked McAlpin to find out what the great man *really* thought, with complete frankness.[19] McAlpin responded at least twice, and perhaps three times;[20] he reported that after further consideration Stieglitz found the exhibition seriously flawed—it projected no sharply focused idea, and only twelve of the sixty pictures met his standards.

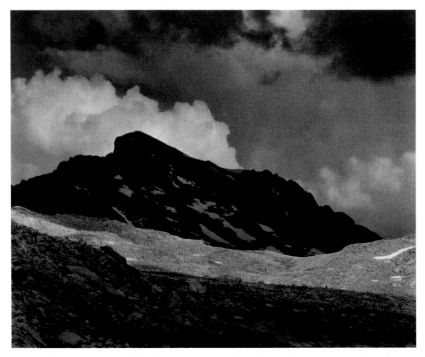 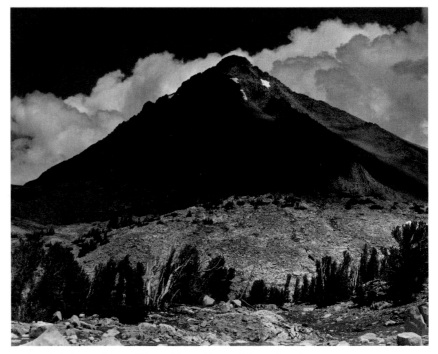

5. Ansel Adams. *The Black Giant, near Muir Pass, Kings Canyon National Park,* 1930. 6. Ansel Adams. *Mount Wynne, Kings Canyon National Park,* c. 1933.

Adams was doubtless disappointed, but he responded rationally and reasonably and tried as well as he could to accommodate Stieglitz's views on the matter. Twelve days later he wrote again, apparently in response to a new letter from McAlpin that reported further reactions from Stieglitz. This letter—a three-thousand-word outpouring—is in turn defensive and accusatory. Although nominally addressed to McAlpin, it is clearly an attempt to answer Stieglitz's reservations, stated or implied, not only about *Sixty Photographs,* but perhaps also about Adams as an artist and as a potential leader of creative photography.

Adams' letter shows us a man who has been deeply hurt: "Stieglitz's remarks about my needing a 'terrible experience' is the corniest thing I have ever heard him say. . . . How can he possibly know what experience I have, or have not had? . . . Stieglitz says there is 'no leadership today.' He wants to climb down in his cyclone cellar with photography under his arm and close the door after him." He also accused Stieglitz and O'Keeffe of being possessed by "intellectual Feudalism," by which he might have meant that creative photography needed exemplars, not leaders. This essay is not the place for an extended consideration of the meanings of this important letter. Perhaps here it is enough to say that his new life

22

had begun badly and that his distrust of New York, of cosmopolitan types, of modern art in general and of the Museum of Modern Art in particular, had been reinforced. It seems likely that even his faith in Stieglitz—the one fixed star in his artistic firmament—was shaken. He continued to revere Stieglitz, but perhaps less as a man and an artist than as a great abstract principle.

During the war Adams continued to spend some time each year at the museum, but travel was difficult, and his initially great enthusiasm for the potential of the department had been dampened. In his correspondence with the Newhalls he now seems to view the institution as an obstacle as often as an opportunity. The situation there was in fact changing. In 1942 and again in 1945 the museum mounted large, dramatic, and very popular theme shows on the war, both directed by the guest curator Edward Steichen.

In the spring of 1946 the Newhalls left the museum in protest when Edward Steichen was about to be appointed director of the department. Adams had disliked Steichen for years, for reasons which were fundamentally chemical, and now he liked him even less, for reasons that had become philosophical also. From California he urged the Newhalls not to collaborate. Whether or not Adams' advice was crucial, the Newhalls did resign, perhaps in hope that the photography community would rise up in protest. If the photography community did that, the museum's board apparently did not notice.

When the Newhalls resigned from the museum's staff Adams angrily resigned from its Photography Committee and was again a full-time photographer.

It would not be surprising if Adams felt that he had a score to settle; or if that is an ungenerous way of putting it, one might say that he would surely welcome the opportunity to demonstrate that his own understanding of photography's potentials was philosophically and artistically superior to that of his nemesis, Steichen. However one puts it, he had an eager ally in Nancy Newhall. Separation from the museum was perhaps a greater blow to her than to her husband; during the war years it had been effectively her department, and it was in large part her program that—as she must have seen it—was being rejected. Even before the war she had been an active collaborator with her husband. But in 1948, when he accepted the position of curator of the George Eastman House, in Rochester, New York, his role was defined in terms of traditional corporate principles; the people from Kodak did not expect to get two people when they hired one, and Nancy Newhall's visible participation in the affairs of George Eastman House was not encouraged. She thus had ample time to pursue independent projects.

23

In the early fifties she and Adams began a history of collaborations, beginning with a series of articles for the magazine *Arizona Highways* and eventually including seven books, of which the most notable was the highly influential *This is the American Earth* (1960). I think it likely that Nancy Newhall had a substantial influence on Adams' work during the postwar years; if that puts the case too strongly, one might say that the character of her contribution was in harmony with changes that were taking place in his work for other or more complex reasons. Nancy Newhall had a taste for prose that ran toward the purple—for hyperbole and exhortation and the declamatory posture—and Adams' work had also begun to incline a little in that direction. In his *Autobiography* Adams compares her introduction to *This is the American Earth* to Genesis. It goes in part like this:

You shall know immensity,

and see continuing the primeval forces of the world.

You shall know not one small segment but the whole of life,

strange, miraculous, living, dying, changing.

Adams was of course her friend, and he was not a dependable critic of his friends' work. I once heard him argue (with an incredulous Brett Weston) that his friend and San Francisco neighbor Benjamin Bufano was a major modern sculptor. But putting aside the issue of quality, there is surely in Nancy Newhall's writing a kind of biblical ambition, a reaching for the larger view, that is not out of keeping with the new character that begins to appear in Adams' work during the war years. The best characteristic work of the thirties was intensely focused and private; writing in the *Autobiography* of his work from the years around 1930 he said, "Few of these photographs were of vast landscapes, most were details, minutiae of nature, and the moods of light and weather on a single mountain or valley."[21] And in 1932 he regretted, in the Sierra Club *Bulletin*, that "the American mode of appreciation is dominantly theatrical—often oblivious of the subtle beauty in quiet, simple things."[22] In the forties, however, Adams began to make the broad, heroic views that became among the general public his most loved pictures. The earlier lyric sensibility was gradually replaced by an epic one, which was perhaps more useful to his evolving ambitions.

There was another factor, a superficially trivial one, that surely effected a change in Adams' work. The characteristic work of the thirties was done while Adams traveled on foot, with his gear on the back of a burro. Later he traveled by station wagon.

There seems to be no rational reason why a photographer should make better pictures on a motif that is difficult to get to than on one that is just outside the car door. One should resist the temptation to think that an artist gets extra credit for attempting a difficult problem, much less for mere physical exertion. Surely it is better to save one's energy for the game at hand rather than to spend it imitating a pack animal or mountain goat. In my own experience, the most tortuous portage (the one that leads through the dankest swamps and over the steepest hills) generally leads to a lake that is—from a photographic point of view—much like the one that was left behind. It is true that the hardest part of photography is finding the right place to stand, but the difference between the wrong place and the right place is as likely to be measured in inches as in miles. The best general rule for photographers might be to stay put if the light is good. Surely the principal reason why so many great photographs have been made with large cameras is that the equipment is heavy, and thus discourages the photographer from confusing photography with hiking.

So the relevant issue might hinge not on ease but on speed. At forty miles an hour Adams could see the potential in the motif that became *Moonrise, Hernandez,* and the event makes a splendid story: the frantic scrambling to get the equipment unpacked and set up while the last rays of the sun were striking the church, with no time to measure the light, et cetera. It is almost like the last moment of a close football game, and we are relieved and glad that he was fast enough and that he got the picture. There are no such stories connected to *Frozen Lake and Cliffs* (Plate 65), where Adams made five lesser pictures, apparently not all on the same day, before he found the vantage point and the moment from which to make the great one.[23] The best answer is not always obvious, even to those of high talent. John Muir, speaking of his efforts to understand the geology of the Yosemite, said, "Patient observation and constant brooding above the rocks, lying upon them for years as the ice did, is the way to arrive at the truths which are graven so lavishly upon them."[24] Lying on the rocks is presumably better than sitting on them because in this posture more of the student comes into intimate contact with the subject.

But perhaps this does not quite close the issue. Perhaps some part of our receptive machinery actually works better when the rest of our system—the part used for workaday obligations—is exhausted. Clarence King described his condition at the end of the first day of his ascent of Mount Tyndall like this: "After such fatiguing exercises the mind has an almost abnormal clearness: whether this is wholly from within, or due to the intensely vitalizing mountain air, I am not sure."[25]

King's comment reminds us of the early note from Adams: "I saw more clearly than I have ever seen before or since the minute detail of the grasses, the clusters of sand shifting in the wind . . ." The difference is that King seems to recall his experience coolly, as a scientist, and Adams reminds us of Saul becoming Paul on the road to Damascus. Adams is seeing the world from some condition of heightened awareness; perhaps he is experiencing the sublime, that condition so often spoken of in the nineteenth century and never satisfactorily defined, but which seems to have been a kind of holy terror, a happy kind of fear—an exaltation that came with the recognition of one's insignificance. As it concerned the natural world, the sublime was most often associated with immensity—with great spaces, cataracts, towering mountains, and the apprehension of enormous power. It is interesting that King, even when looking into the luxuriant verdure of Yosemite in springtime, spoke of its "geological terribleness" as being merely veiled by magic curtains. King was an enthusiastic disciple of John Ruskin, who said that "natural history is in one sense [not] peaceful but terrific."[26] King praised Ruskin's conception of nature for being similar to that of the *Rig Veda*, the oldest of sacred Hindu writings.[27] In Rigvedic theology mountains and storms are associated with Rudra, a god more feared than loved.

The artist who attempts to express the sublime is of course courting danger, is living just one false step from windy rhetoric on one side and synthetic simplicity on the other. Since the idea cannot be adequately defined within the rules of logic or science or aesthetics or law, it might seem better to call it ineffable and proceed to the next question. But what had earlier seemed ineffable is what the best art describes; and besides, one cannot properly ask an artist to avoid danger, not even foolhardy danger, if he has set his cap for it, and the thing that Adams most wanted to do as an artist was to photograph his mountains as a holy place.

He never put it quite so bluntly; he was a rational man living in a secular society. But he often came close. He insisted on the spiritual value of wild land, and once, in anger, he compared the practices of the National Park concessionaires to the selling of peanuts in the aisles of the church.[28] But he did not send the letter. On reading it over perhaps it seemed emotionally extravagant, a little unbalanced, not politically useful, counterproductive.

As his life advanced, the wild places that he loved became smaller and more isolated, and protected—when protected at all—not by space and natural obstacles but by laws and vigilant oversight and litigation, and infrequently by persuasion. As Adams found himself compelled to take an increasingly

responsible role in conservation politics, his relationship to the land became less that of artist and more that of curator. The free and intuitive exploration of an artistic impulse does not meld easily with the careful morality of the guardian's responsibilities. Passion and duty speak different languages. In the fifties Adams' production of new pictures diminished precipitously, and in the sixties it slowed to a trickle. Finally his life as a photographer became largely a matter of reprinting (and reinterpreting) his earlier negatives, not always to their advantage. There is the suggestion of desperation in the heightened rhetoric of these melodramatic reinterpretations. One is reminded of the ambivalence of Alexis de Tocqueville as he foresaw the triumphant march of civilization across the continent: "One feels proud to be a man, and yet at the same time one feels I cannot say what bitter regret at the power that God has granted us over nature."[29]

Some younger photographers, no less concerned than Adams with our relationship to the natural site, have turned away from the celebrated monuments, the most prized fragments of the aboriginal world, in the belief that such places are now too unfamiliar to save us, and that we must work our way back to health by learning to love our own backyards, as modest as they are, and even the weeds in vacant lots. Others have come to photograph the great parks not as wild places but as government-sponsored entertainment centers. But Adams had no taste for irony, or talent for it; he wrote scores of letters protesting the carnival atmosphere that sometimes poisoned the spirit of the parks, but he could not bring himself to photograph it. Nor would he abandon his belief in the exemplary value of extraordinary places, of which Yosemite and the High Sierra were for him the most special. They had defined the shape and meaning of his life.

1. Clarence King, *Mountaineering in the Sierra* (New York: Charles Scribner's Sons, 1907), pp. 165–166.
2. Mark Twain, *The Works of Mark Twain*, Vol. 2, *Roughing It* (Berkeley; University of California Press, 1972), p. 141.
3. *Eloquent Light*, p. 44; but see *Letters* for full version (March 1927).
4. C. R. Leslie, R. A. *Memoirs of the Life of John Constable, Composed Chiefly of His Letters.* (London: Phaidon Press, 1951), p. 86.
5. For a brief summary of critical response to Matisse in the early thirties see Alfred H. Barr, Jr., *Matisse: His Art and His Public* (New York: Museum of Modern Art, 1951), pp. 222–223.
6. The Rexroth letter does not seem to have survived, but a carbon copy of Weston's answer, dated May 3, 1931, was given to the Museum of Modern Art by Willard Van Dyke, who informed the author that he had typed it for Weston. Rexroth's name does not appear on the letter, perhaps because Weston preferred to write the salutation by hand.
7. Five of Adams' photographs were reproduced to illustrate Paul Taylor's article "Mexicans North of the Rio Grande" in the May 1931 issue of *Survey Graphic*. Taylor did not know Adams, nor had he met his own future wife, Dorothea Lange.

8. Ansel Adams to Beaumont Newhall, January 12, 1937. Courtesy of the Ansel Adams Archive, Center for Creative Photography, University of Arizona.

9. For example, John Szarkowski, Introduction, *The Portfolios of Ansel Adams* (Boston: The New York Graphic Society, 1977), p. viii ff.

10. Panchromatic film was sensitive to all the colors of the spectrum, which meant that photographers could, for the first time, control the tonal relationship of any color and its complementary color by photographing through colored filters. A yellow filter will make yellow objects appear lighter and blue darker, thus facilitating the photography of skies, which resulted in photographs with lower horizons.

11. Henri Cartier-Bresson to Nancy Newhall, in conversation, spring 1952. Reported in Newhall, "Controversy and the Creative Concepts," *Aperture* 2, no. 2 (1953), p. 6.

12. This estimate of the total printing was provided by Fran Moore of the Oxford University Press.

13. Clarence King, *Mountaineering*, p. 16.

14. Thurman Wilkins and Caroline Lawson Hinkley, *Clarence King: A Biography*, rev. ed. (Albuquerque: University of New Mexico Press, 1988), note, p. 389.

15. Ansel Adams, undated fragment quoted by Nancy Newhall in *The Eloquent Light* (San Francisco: Sierra Club, 1963), pp. 36–37.

16. In 1979 the Museum of Modern Art mounted the exhibition *Ansel Adams and the West*, which was selected by me. Sixty-nine percent of the pictures in that exhibition were made before 1945. The exhibition was accompanied by a new book of Adams photographs entitled *Yosemite and the Range of Light*, which was selected by Adams. Fifty-one percent of that selection was made before 1945. I think that these numbers would be even more lopsided if one considered only the pictures that Adams had actually published before and after the beginning of 1945. By the time Adams selected the photographs for the 1979 book he was reviewing his negative file, and it would have been natural for him to select from his early work neglected negatives that satisfied his later views.

17. Ansel Adams, *Making a Photograph: An Introduction to Photography* (London: Studio Publications, 1935).

18. Ansel Adams, *An Autobiography* (Boston: Little, Brown, 1985), p. 203.

19. Adams to McAlpin, January 1, 1941. Courtesy William A. Turnage.

20. McAlpin wrote to Adams on January 14 (files of the Museum of Modern Art) and again on January 16 (courtesy Bill Turnage). The earlier letter was written by hand, the latter exists in what seems to be a typewritten copy of later date. Adams' first reply, of January 22 (courtesy Bill Turnage) seems to respond only to the content of McAlpin's January 16 letter. Adams' second response, begun on February 3 and completed on February 7 (courtesy Virginia Adams), seems to respond to the January 14 letter. Adams was at Yosemite Valley at the time, and it is possible that winter conditions there might have affected the delivery of mail.

21. Adams, *An Autobiography*, p. 142.

22. Ibid., p. 148.

23. For an extended analysis of this series of attempts with the same subject matter, see "Kaweah Gap and Its Variants" by John Szarkowski in *Ansel Adams 1902–1984* (Carmel: The Friends of Photography, 1984), pp. 12–15.

24. Quoted by William E. Colby, in his Introduction to *Studies in the Sierra*, by John Muir (San Francisco: Sierra Club, 1950), p. xxi.

25. Clarence King, *Mountaineering*, p. 71.

26. E. T. Cook and Alexander Wedderburn, eds., *The Works of John Ruskin* (London: 1903–1912), Vol. 36, p. 380; quoted in John Hayman, *John Ruskin in Switzerland* (Waterloo, Ontario: Wilfred Laurier University Press, 1990), p. 5.

27. Wilkins and Hinkley, *Clarence King*, p. 41.

28. The long, haranguing 1948 letter was to Charles Woodbury, the chairman of a committee formed to look into the relationship between the parks and their private operators. The letter is quoted by Nancy Newhall in the manuscript for the unpublished Volume 2 of her biography of Adams, p. 558. Courtesy Virginia Adams.

29. Alexis de Tocqueville, *Journey to America* (Garden City, N.Y.: Doubleday Anchor, 1971), p. 399.

Yosemite and the High Sierra

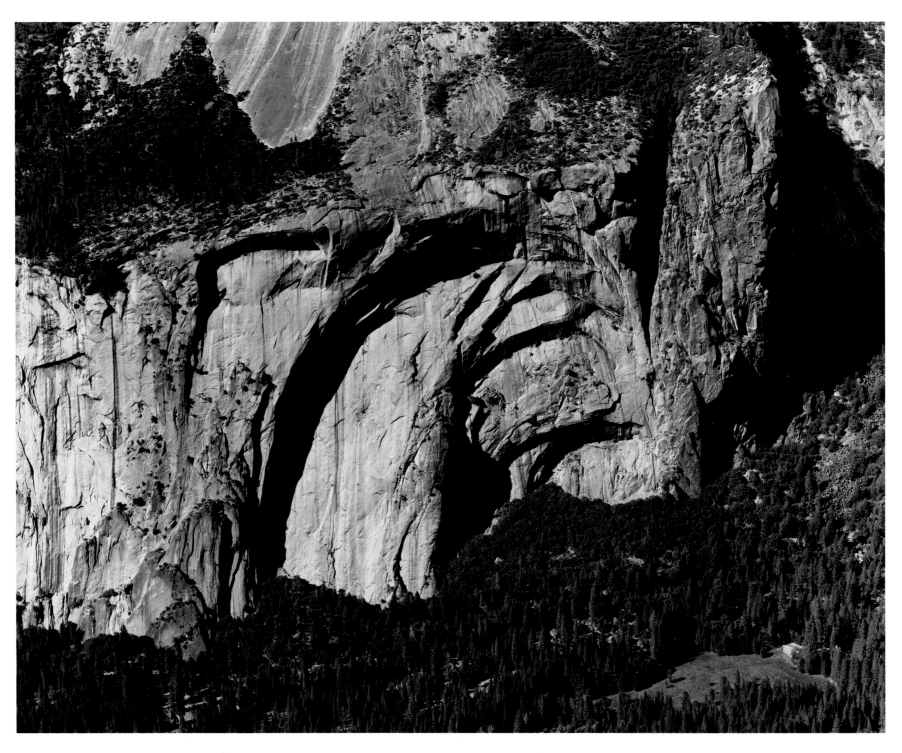

7. Royal Arches from Glacier Point, Yosemite National Park, c. 1940

8. El Capitan from Taft Point, Yosemite National Park, c. 1936

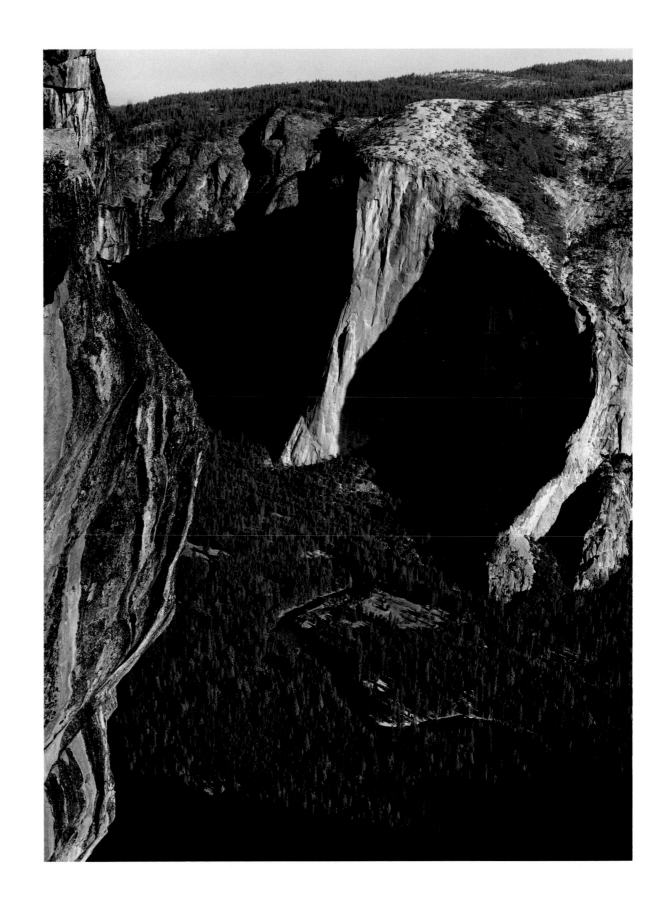

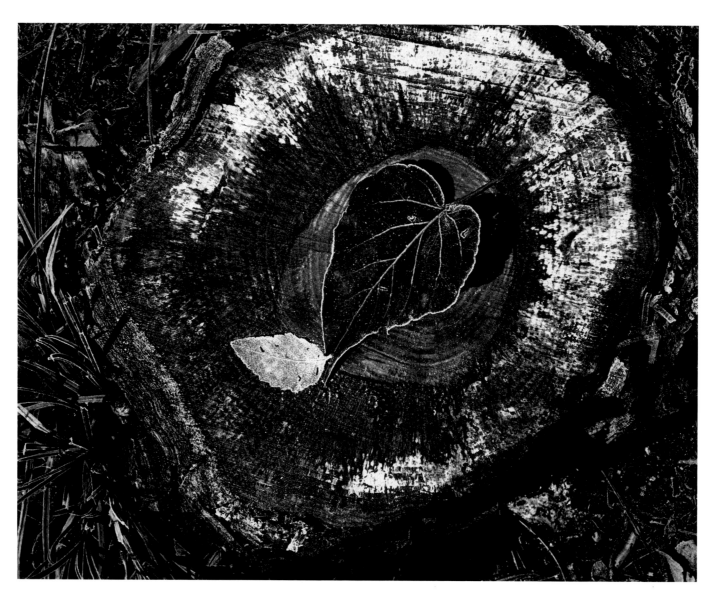

9. Leaves, Frost, Stump, October Morning, Yosemite National Park, c. 1931

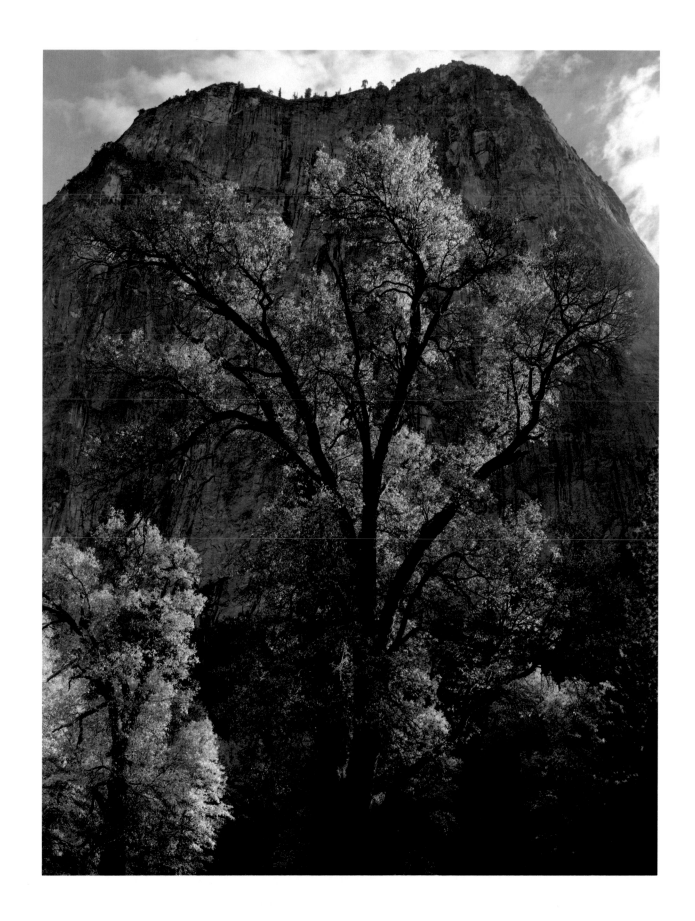

10. Autumn Tree against Cathedral Rocks,
Yosemite National Park, c. 1944

That first impression of the valley—white water, azaleas, cool fir caverns, tall pines and stolid oaks, cliffs rising to undreamed-of heights, the poignant sounds and smells of the Sierra . . . was a culmination of experience so intense as to be almost painful. From that day in 1916 my life has been colored and modulated by the great earth-gesture of the Sierra.

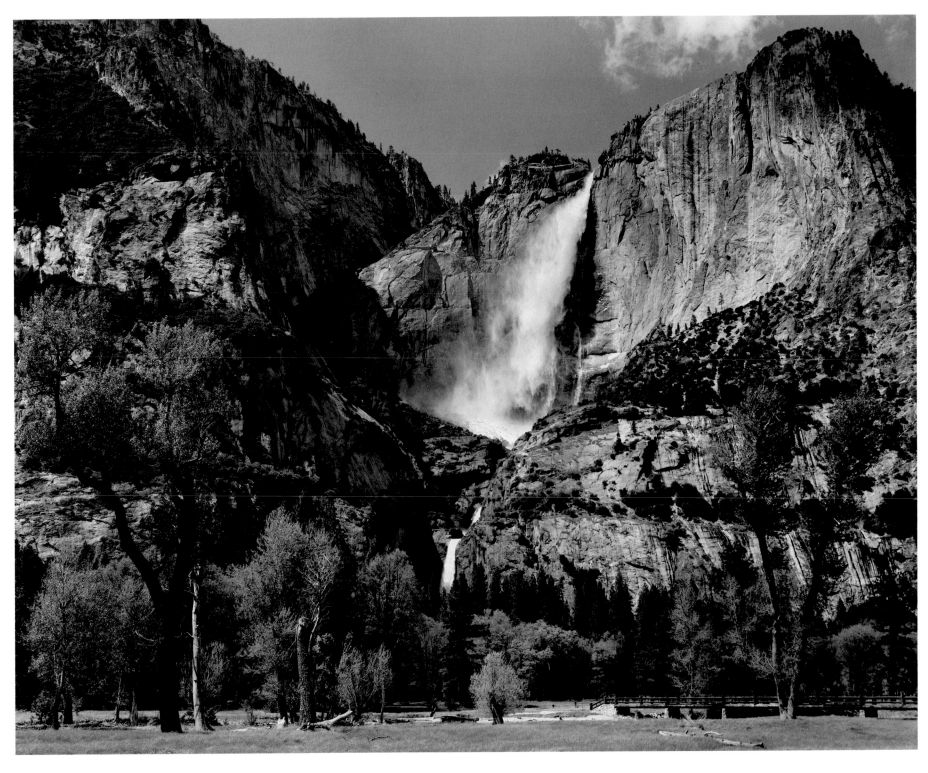

11. Yosemite Falls, Yosemite National Park, c. 1953

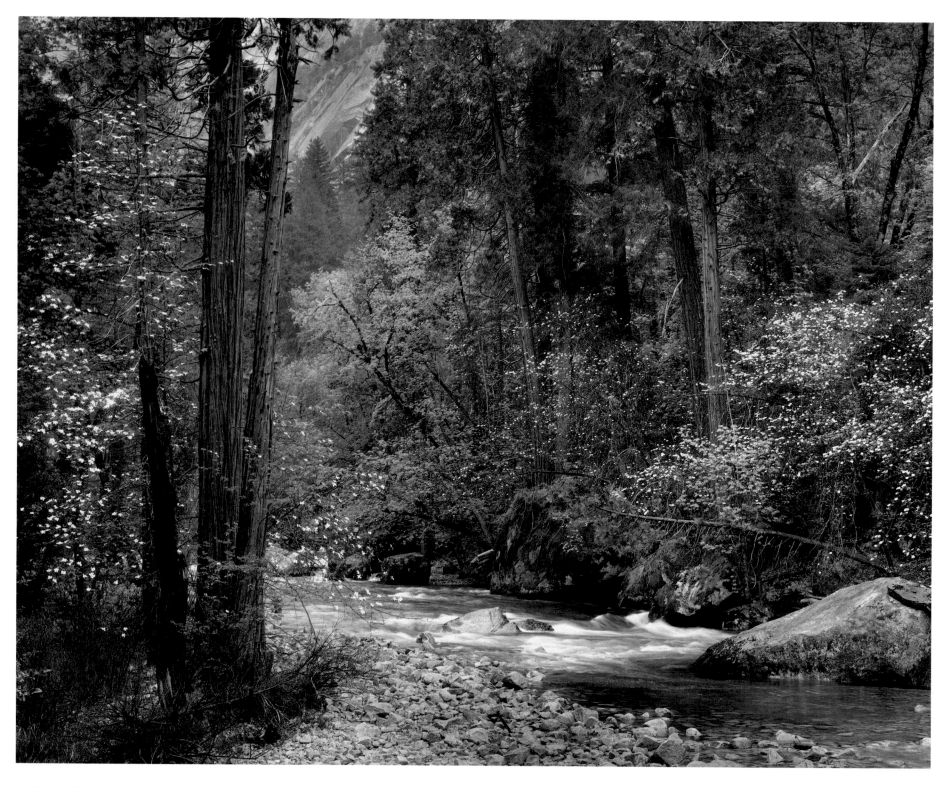

12. Tenaya Creek, Dogwood, Rain, Yosemite National Park, c. 1948

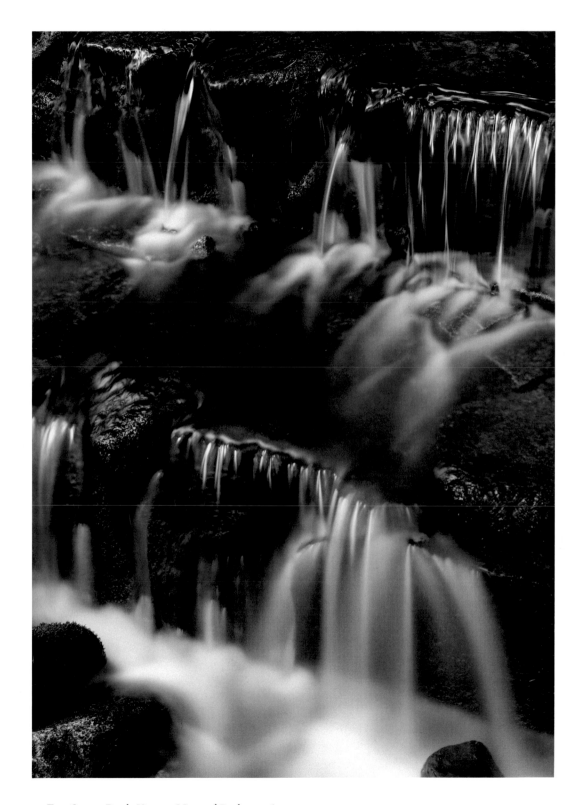

13. *Fern Spring, Dusk, Yosemite National Park, c. 1961*

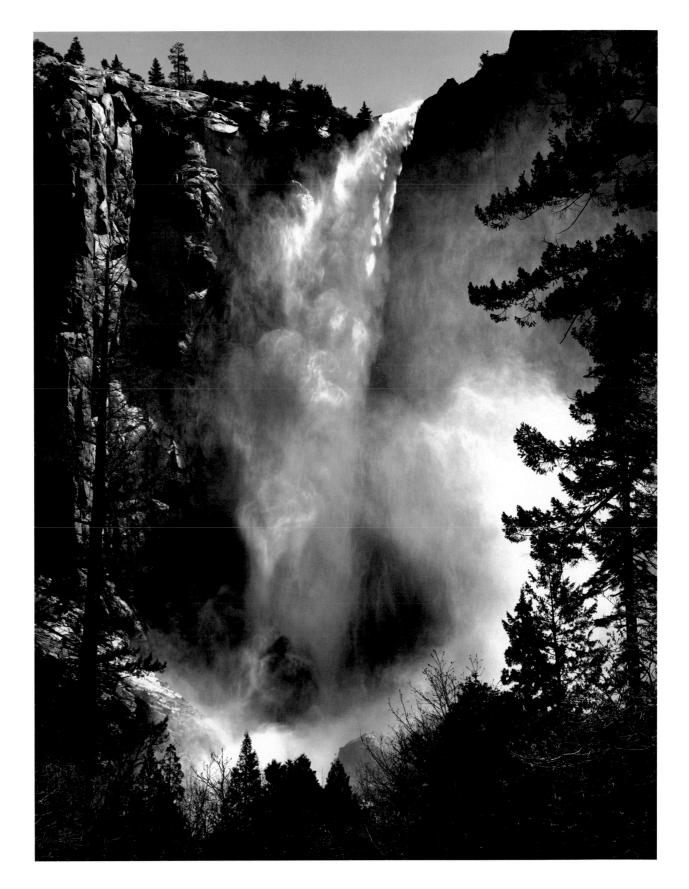

14. Bridalveil Fall, Yosemite National Park,

c. 1927

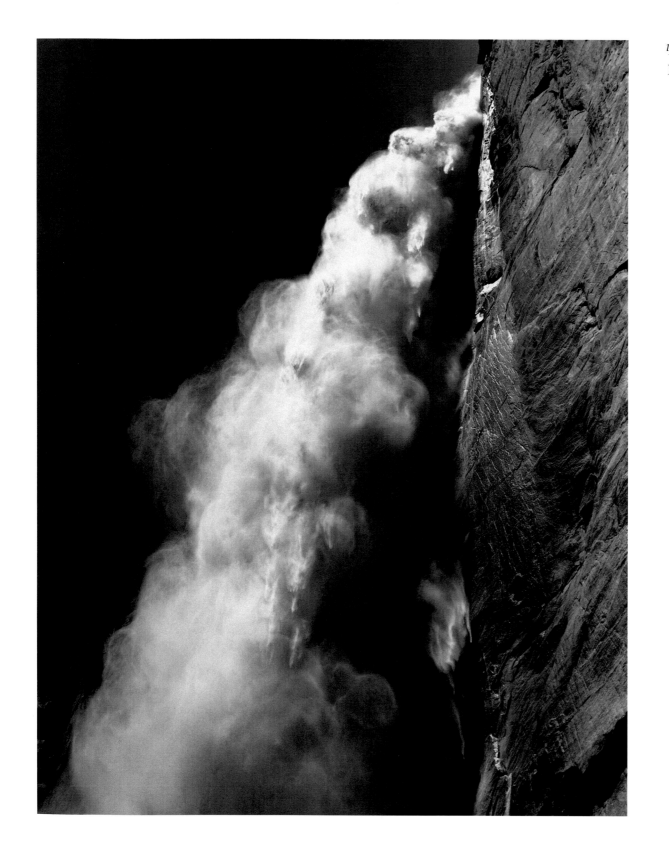

15. *Upper Yosemite Falls, from Fern Ledge,*
Yosemite National Park, 1946

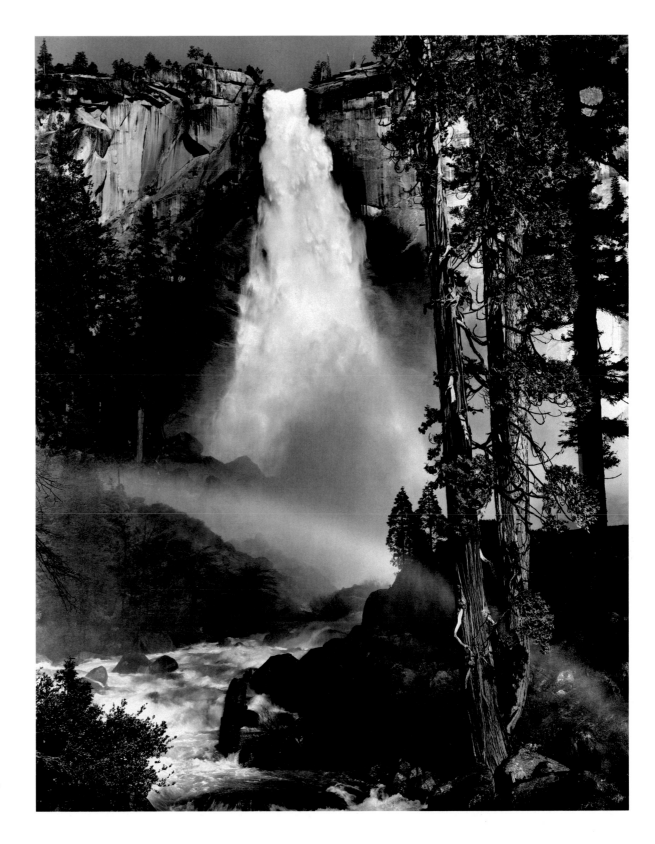

16. Nevada Fall, Rainbow, Yosemite National Park,

1946

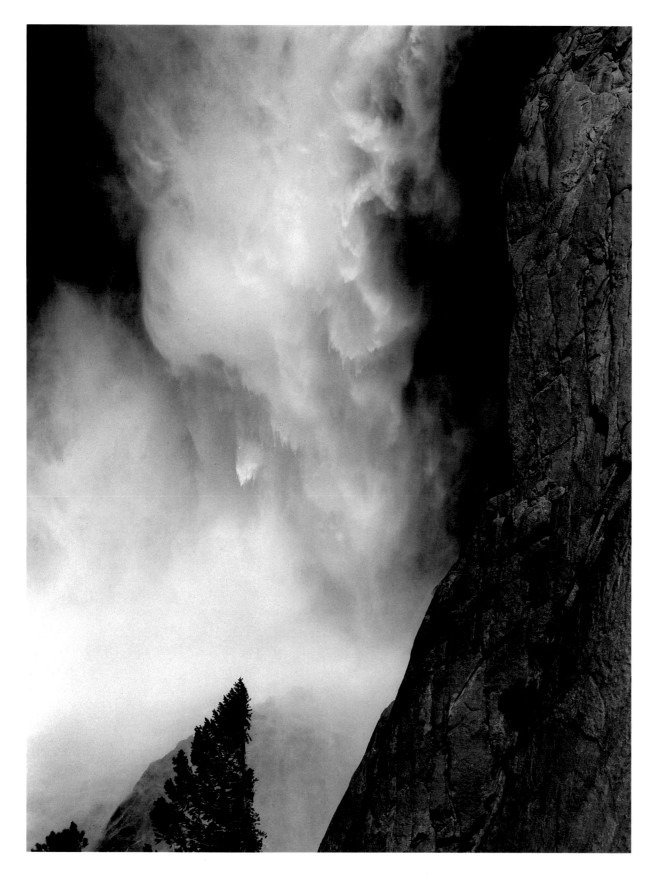

17. Base of Upper Yosemite Falls, Yosemite National Park, c. 1948

Yet the grandest sounds of all are those of the waterfalls in spring booming and thundering in high flood . . .

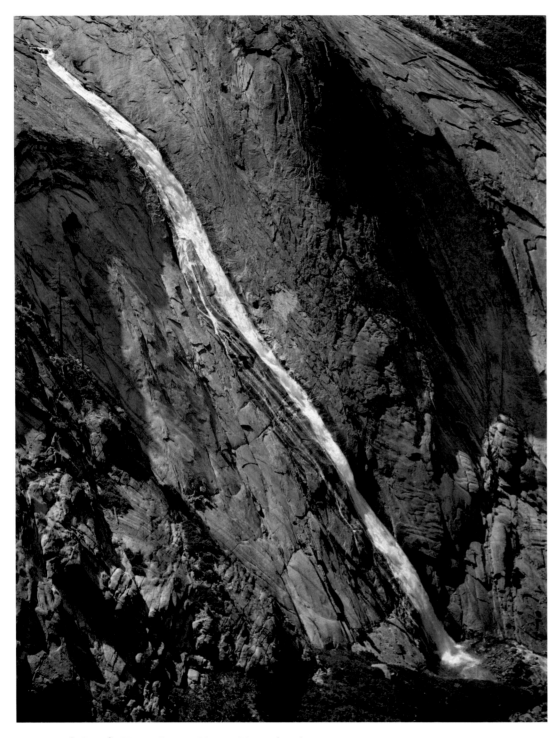

18. Pywiack Cascade, Tenaya Canyon, Yosemite National Park, c. 1940

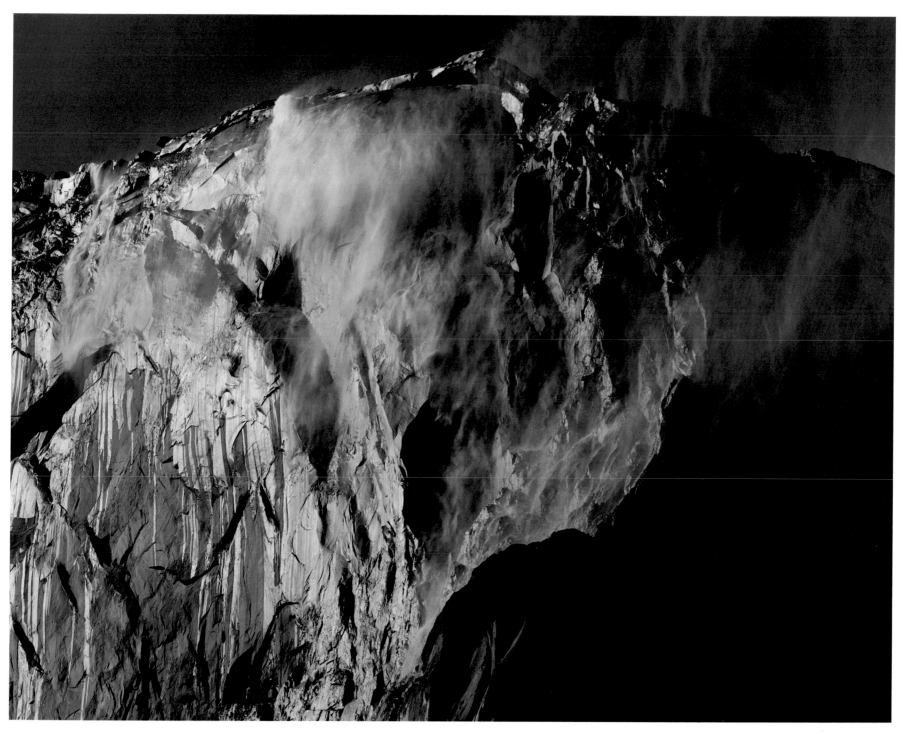

19. El Capitan Fall, Yosemite National Park, c. 1940

I have photographed Half Dome innumerable times, but it is never the *same* Half Dome, never the same light or the same mood.

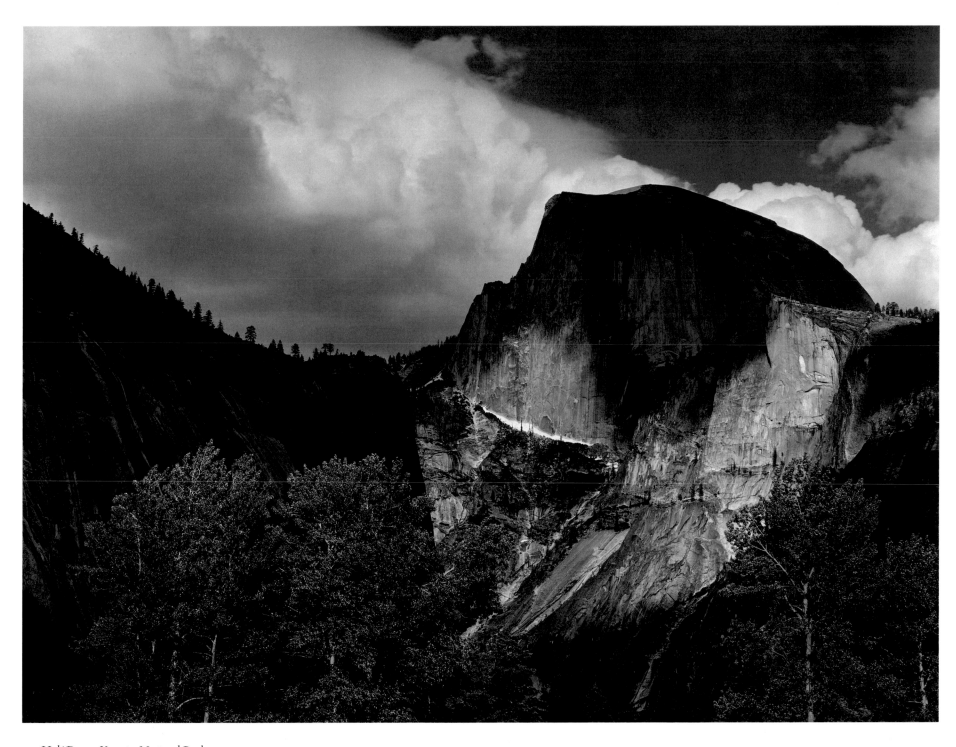

20. Half Dome, Yosemite National Park, 1932

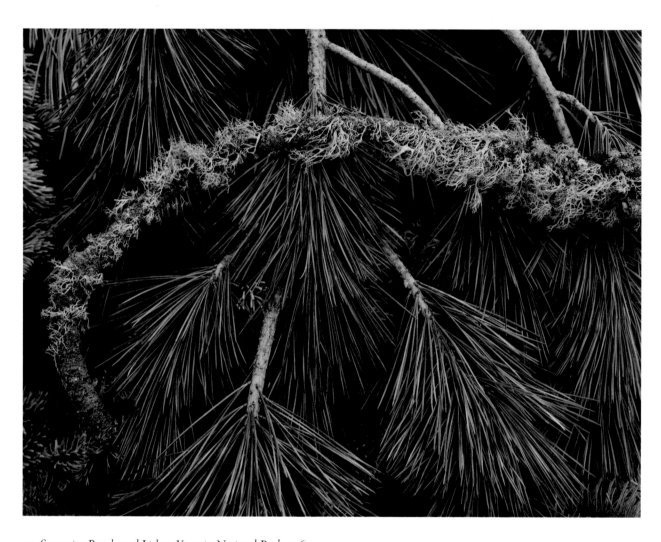

21. Sugarpine Boughs and Lichen, Yosemite National Park, 1962

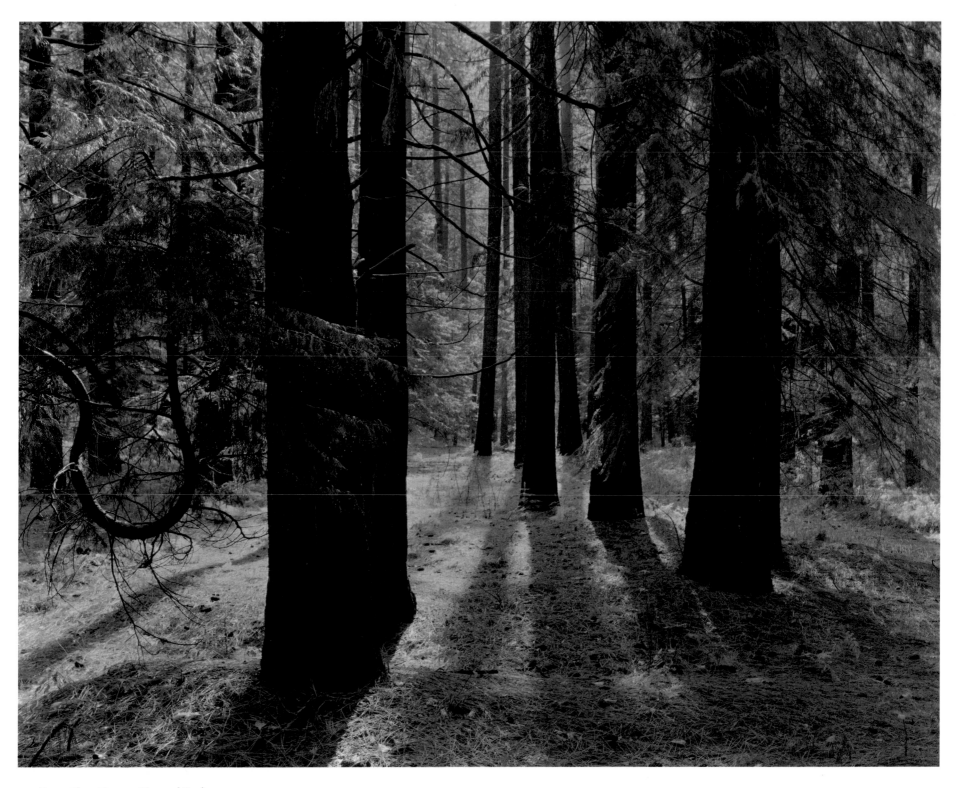

22. Forest Floor, Yosemite National Park, c. 1950

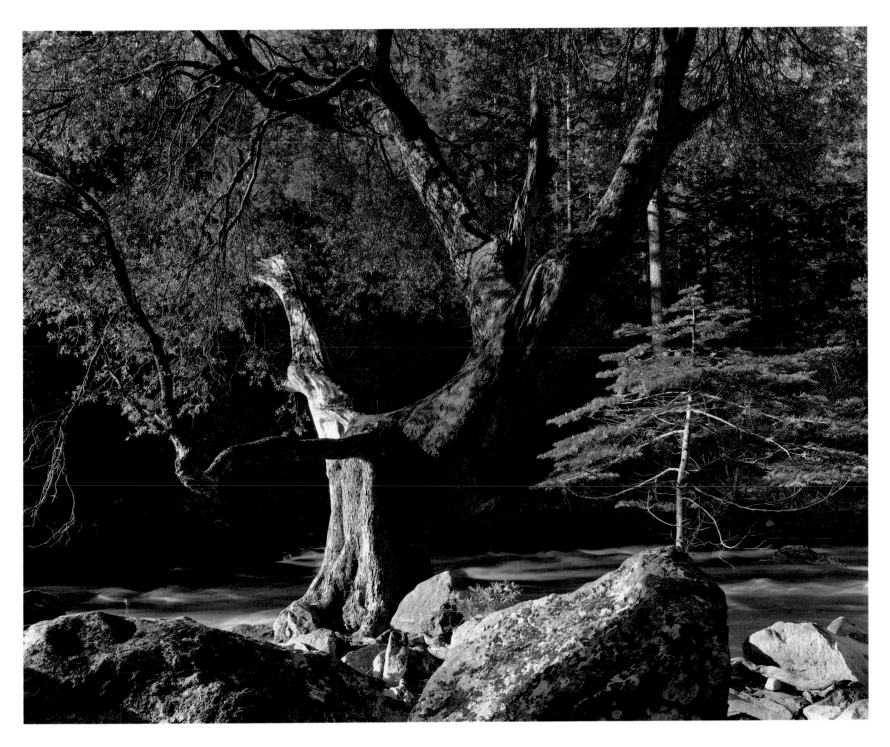

23. *Early Morning, Merced River, Yosemite National Park, c. 1950*

Yosemite Valley, to me, is always a sunrise, a glitter of green and golden wonder in a vast edifice of stone and space.

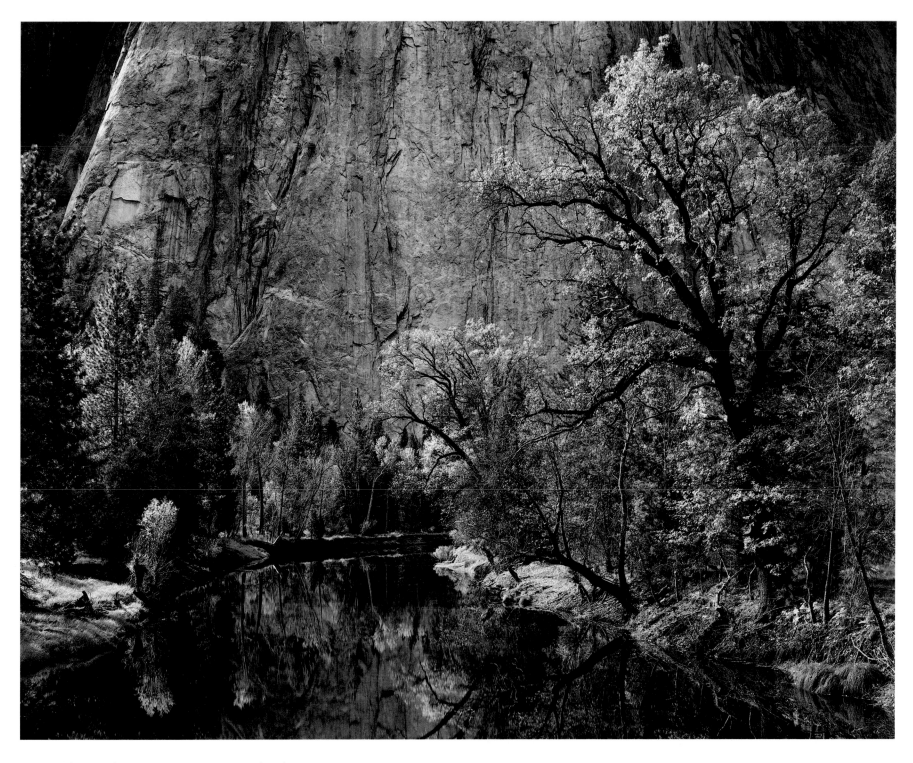

24. Merced River, Cliffs, Autumn, Yosemite National Park, c. 1939

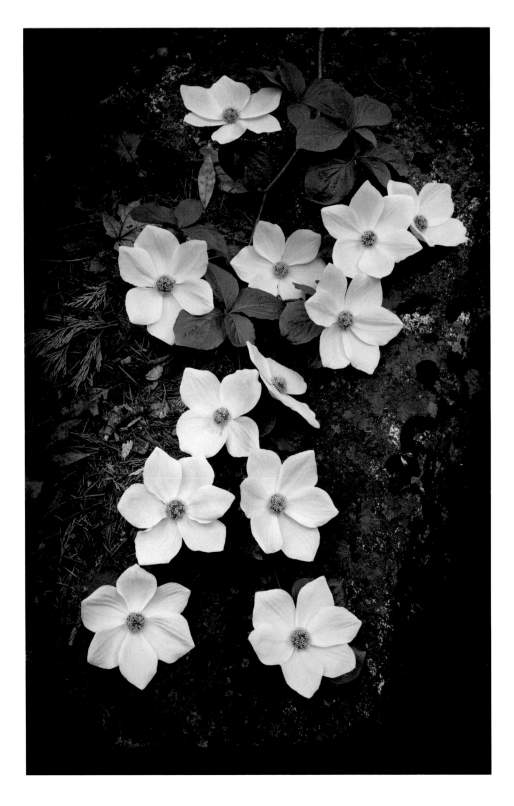

25. Dogwood, Yosemite National Park, 1938

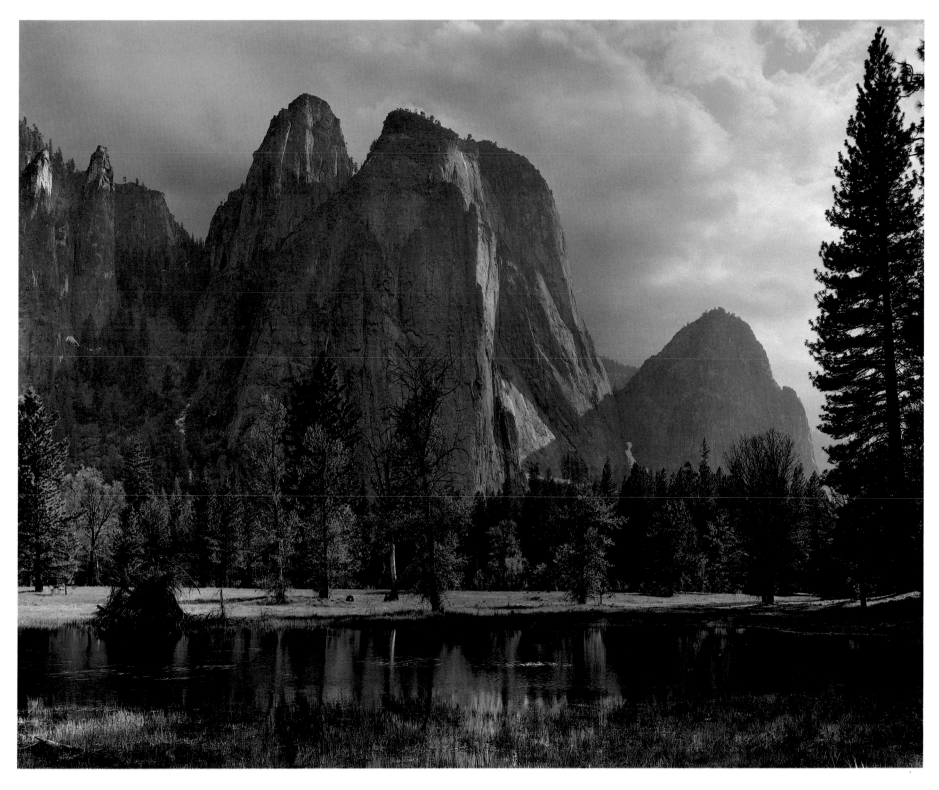

26. Cathedral Rocks, Yosemite National Park, c. 1949

The great rocks of Yosemite, expressing qualities of timeless, yet intimate grandeur, are the most compelling formations of their kind. We should not casually pass them by for they are the very heart of the earth speaking to us.

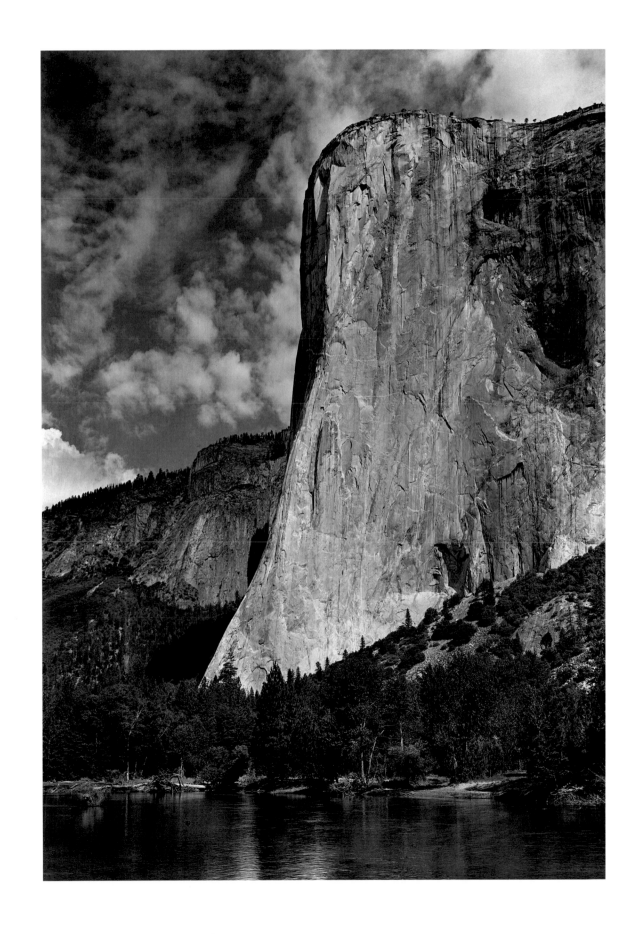

27. El Capitan, Merced River, Clouds,
Yosemite National Park, c. 1952

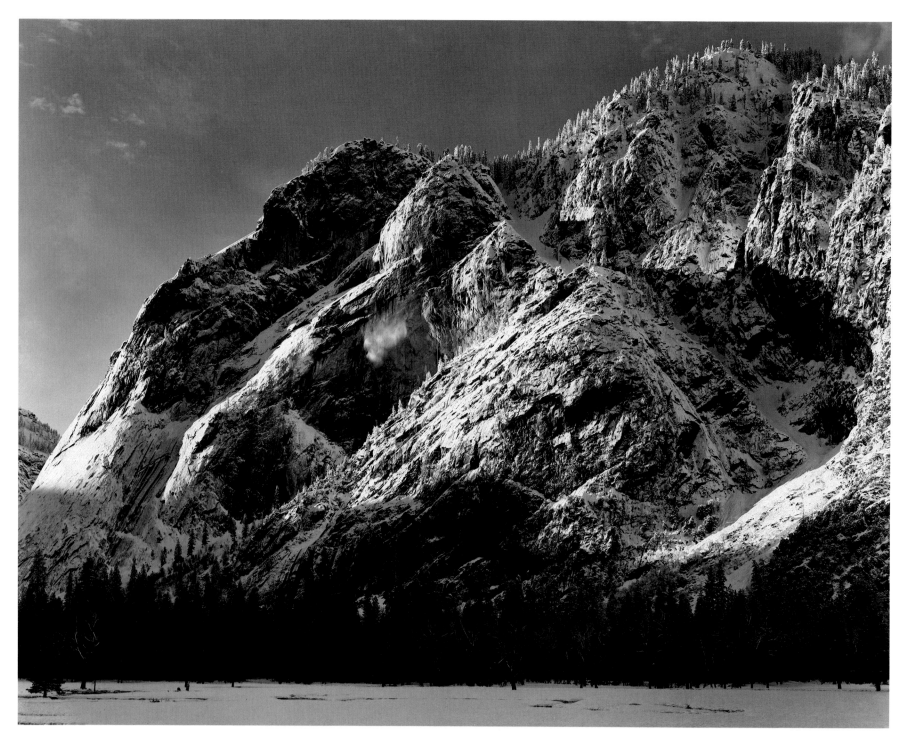

28. Cliffs of Glacier Point, Avalanche, Yosemite National Park, c. 1939

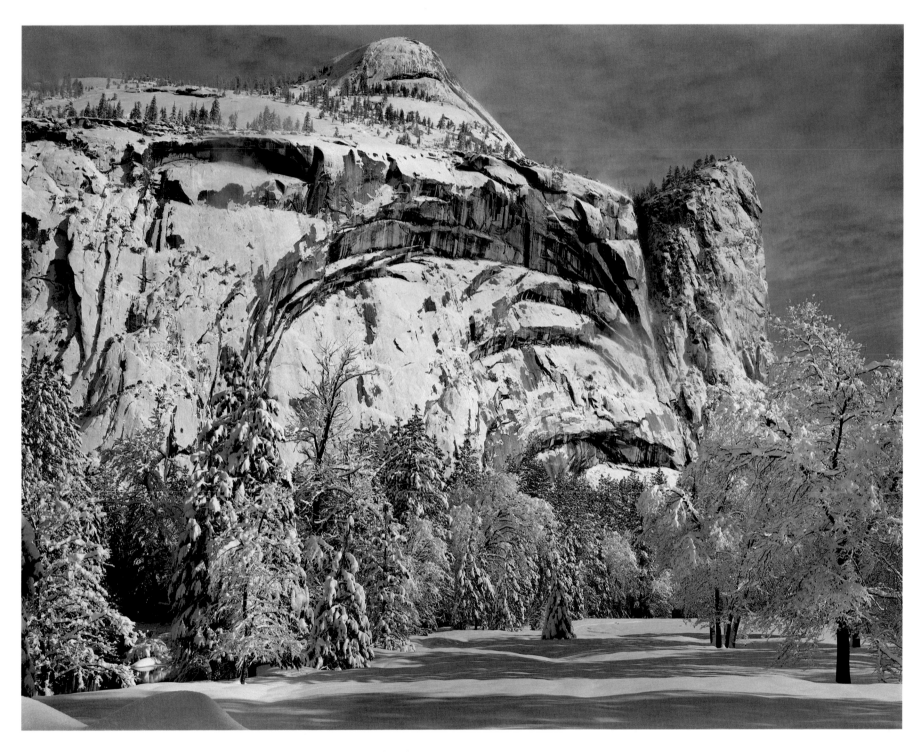

29. North Dome, Royal Arches, Washington Column, Winter, Yosemite National Park, 1947

In time of storm the clouds seek each other among the crags, and snow falls quietly, whitely, lavishly, filtering into the deepest recesses of the forest, powdering tree and stone and piling high in the gorges and grottoes of the cliffs. As the clouds break a dazzling shining world appears, unearthly and quiet except for the mutter and boom of distant avalanches and the near thudding of fresh snow dropping from the pines.

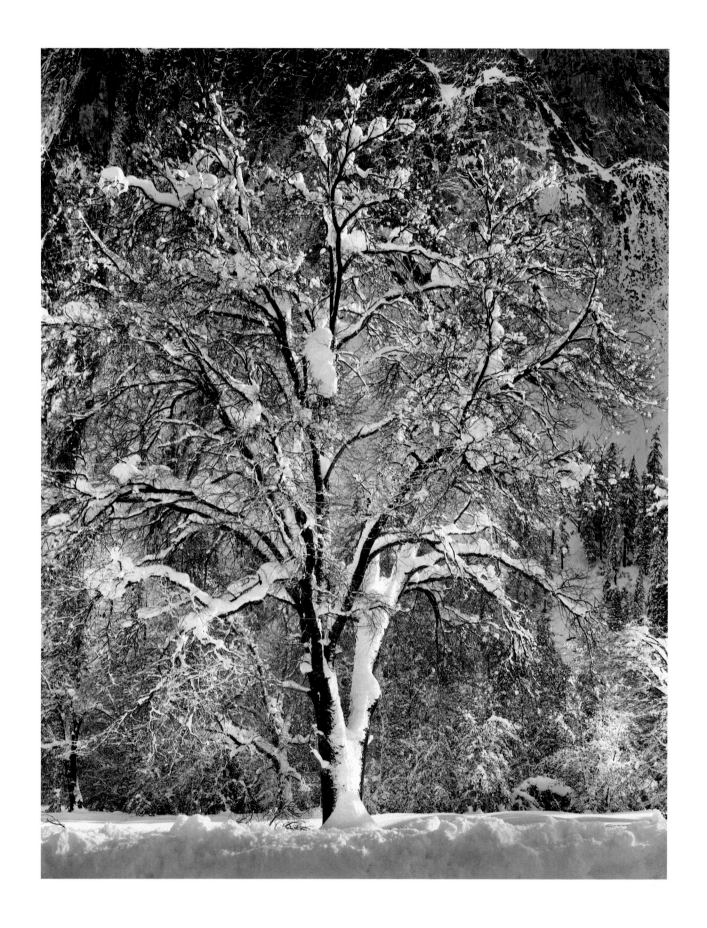

30. Oak Tree in Snow,
Yosemite National Park, c. 1933

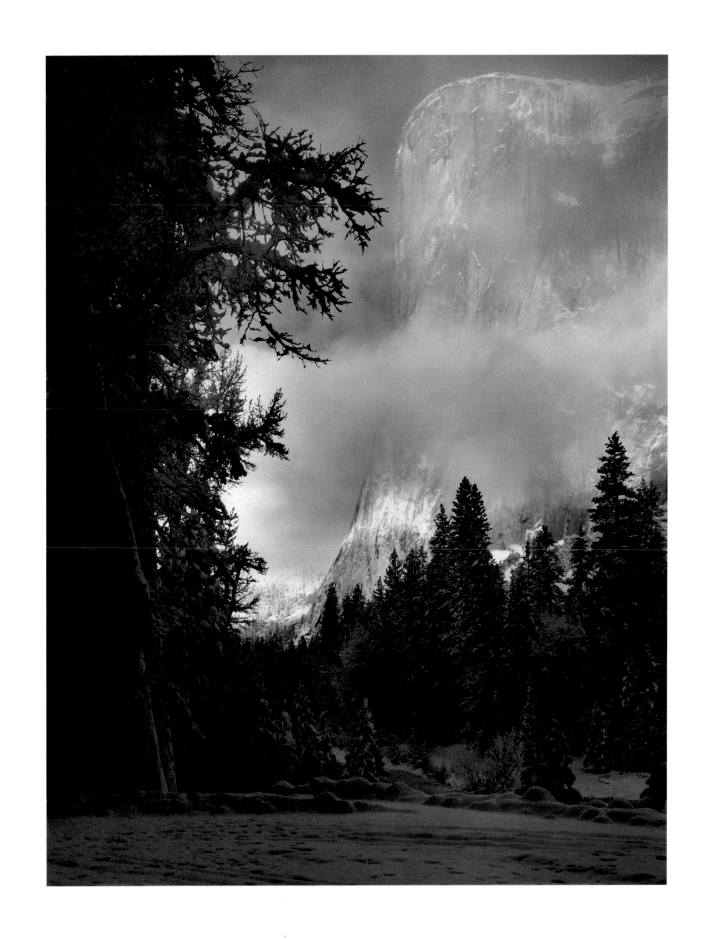

31. El Capitan, Winter Sunrise,
Yosemite National Park, 1968

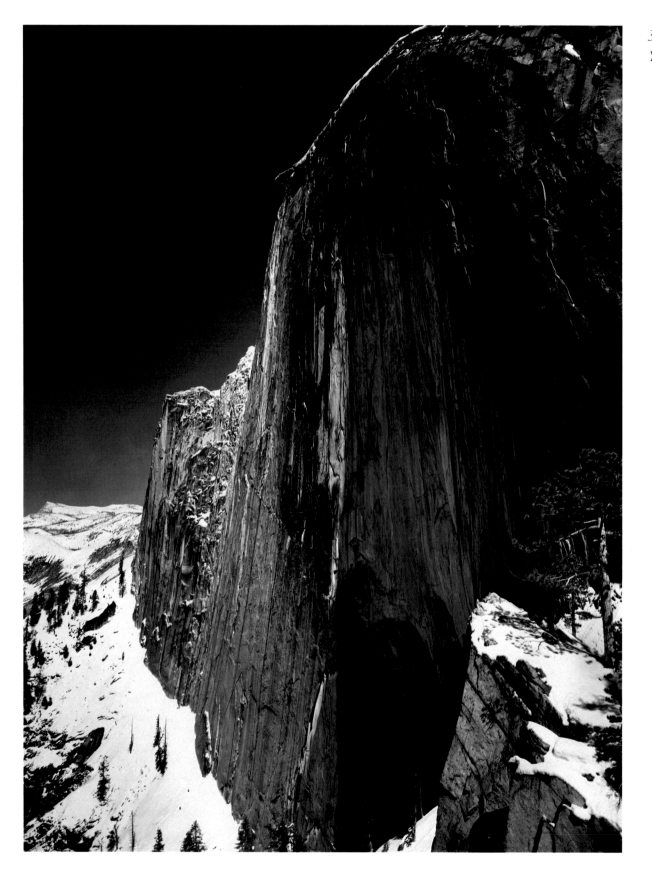

32. Monolith, The Face of Half Dome,
Yosemite National Park, 1927

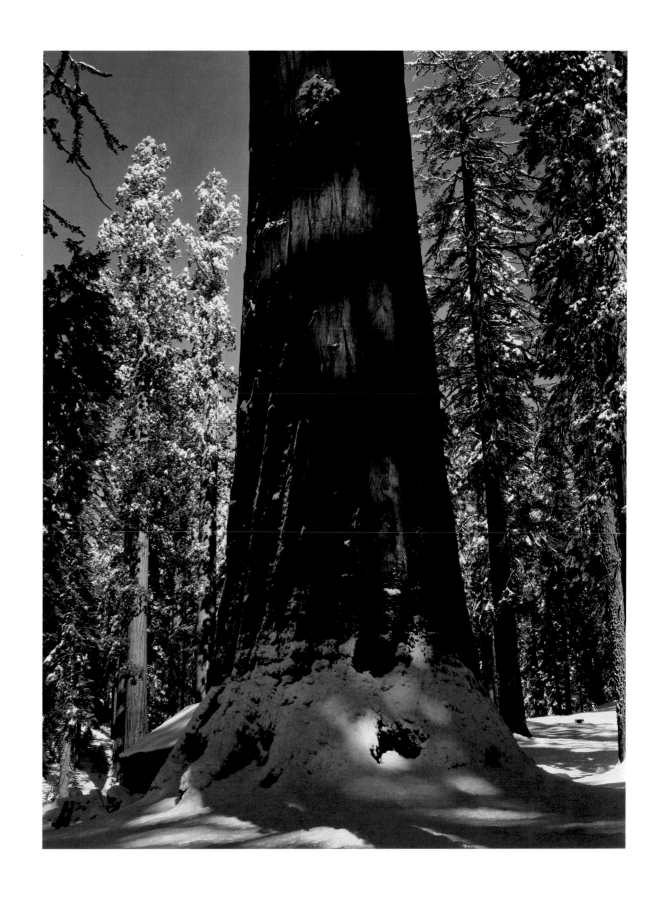

33. Redwood Tree, Mariposa Grove, Winter,
Yosemite National Park, c. 1937

On a winter morning we may awake to a fantastic world of white—the cliffs solidly iced, and six-inch-high blades of powdery snow on every branch and twig. . . .

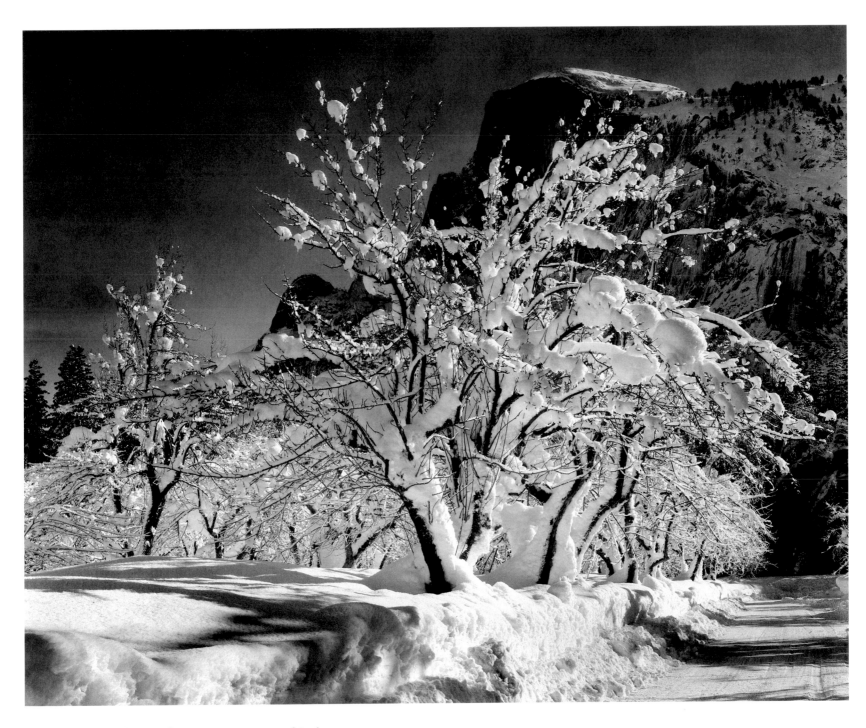

34. Half Dome, Apple Orchard, Winter, Yosemite National Park, c. 1930

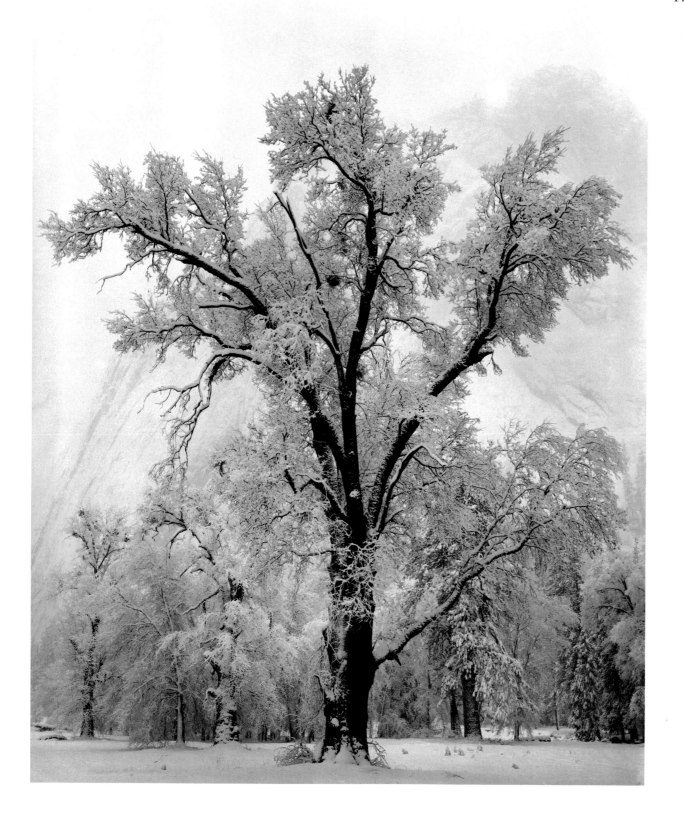

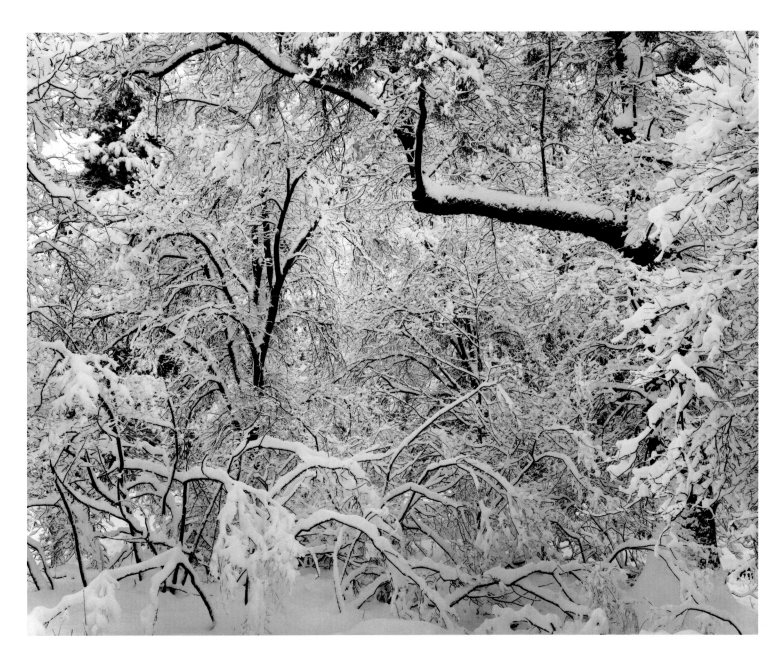

36. Fresh Snow, Yosemite National Park, c. 1947

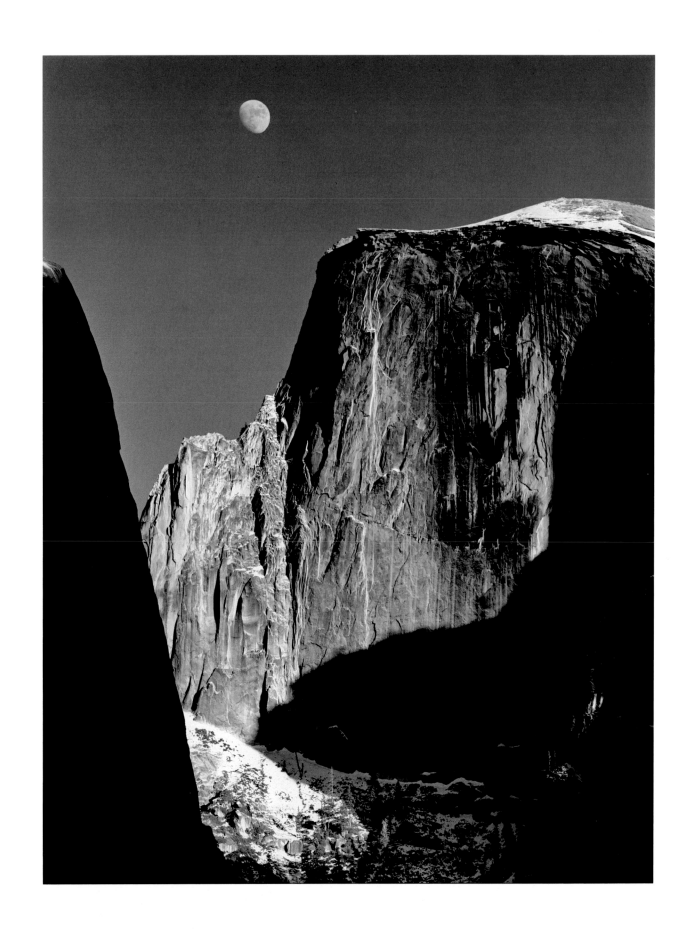

37. Moon and Half Dome, Yosemite National Park, 1960

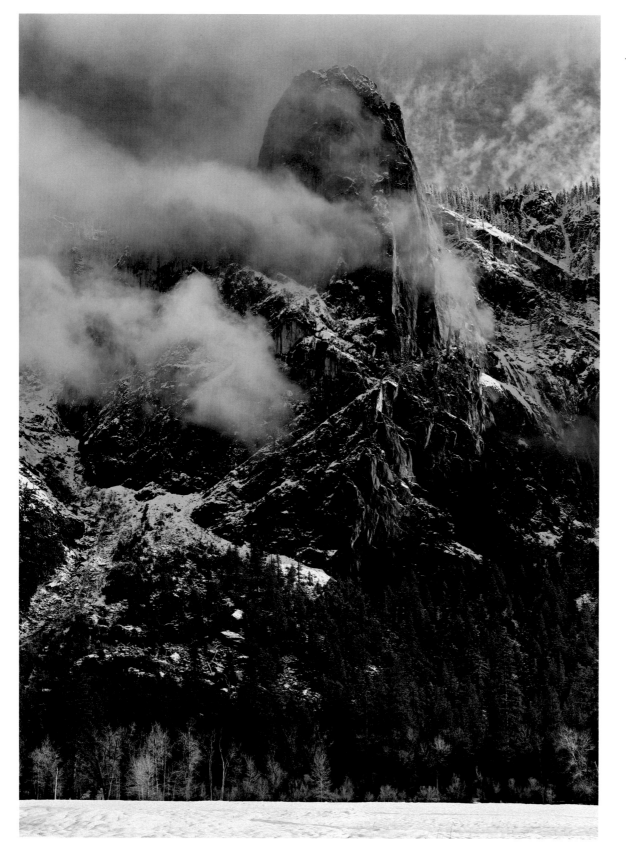

38. Sentinel Rock and Clouds, Winter, Yosemite National Park, c. 1937

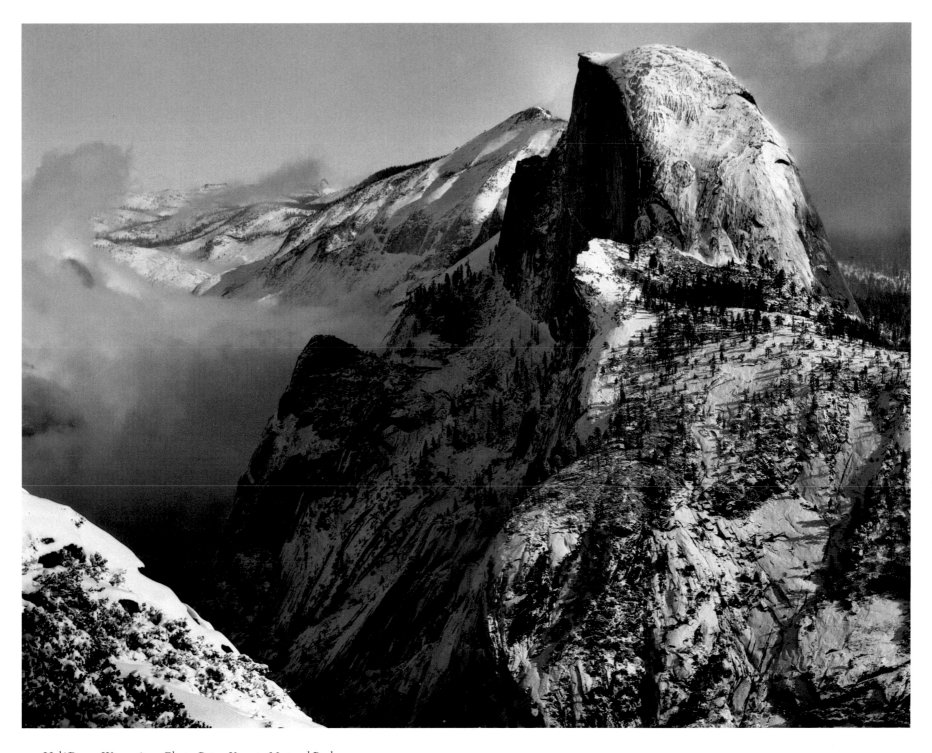

39. Half Dome, Winter, from Glacier Point, Yosemite National Park, c. 1940

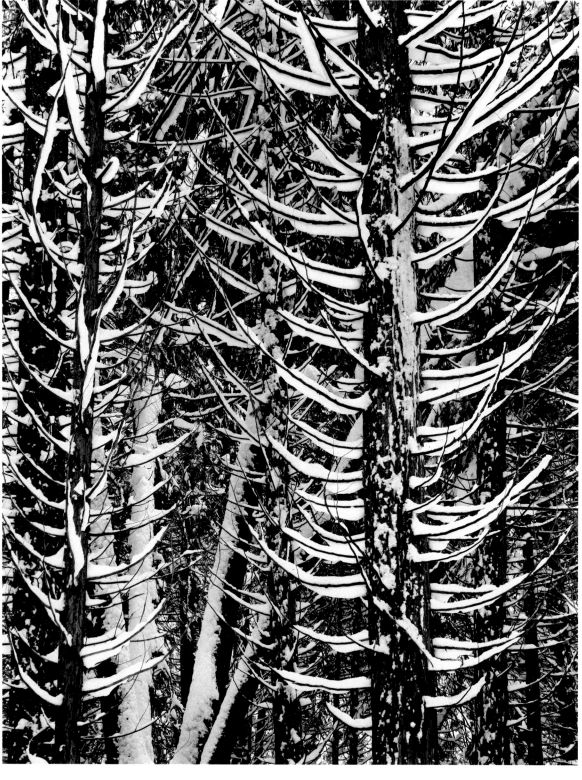

41. Trees and Cliffs of Eagle Peak, Winter, Yosemite National Park, c. 1935

Tomorrow I am off for the High Mountains—back to my paradise for a good, long soul-building rest.

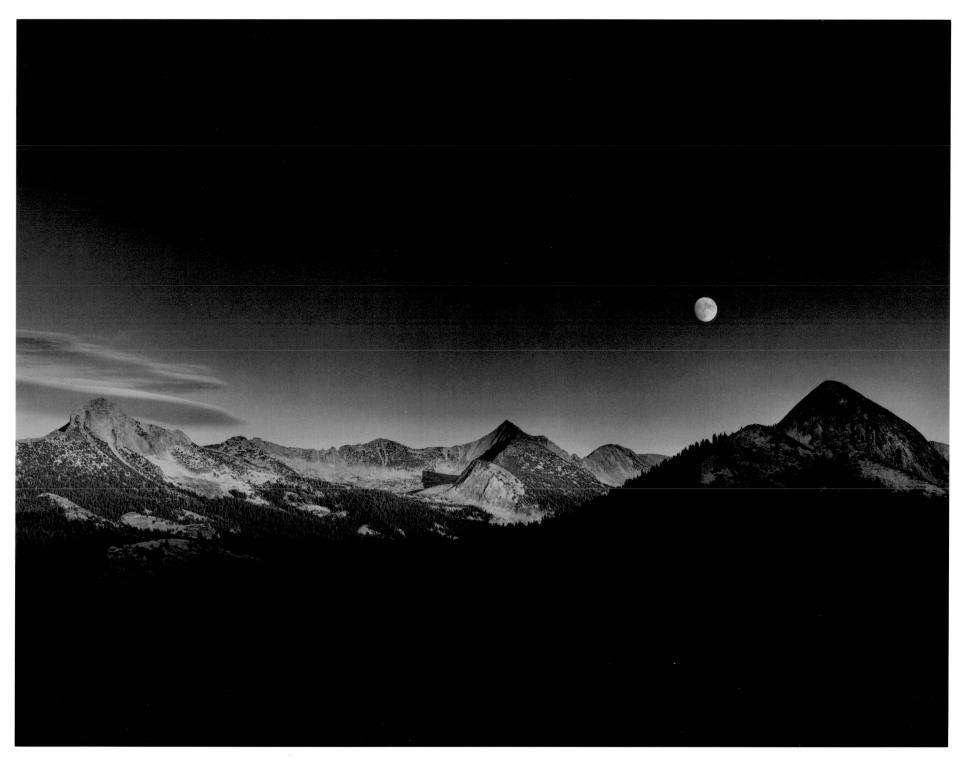

42. *Autumn Moon, High Sierra from Glacier Point, Yosemite National Park, 1948*

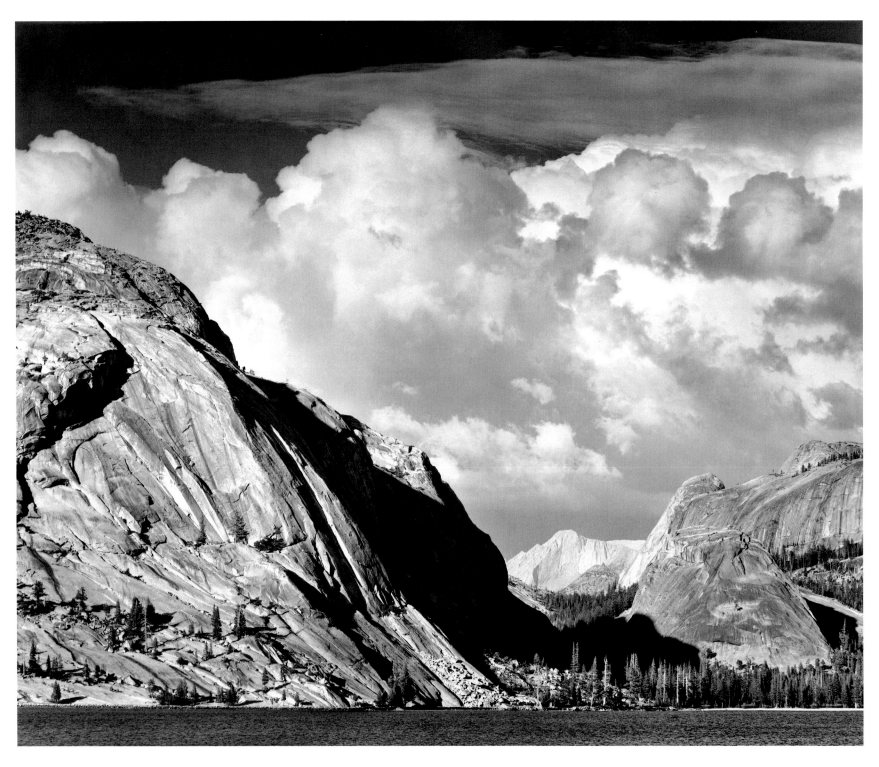

43. *Tenaya Lake, Mount Conness, Yosemite National Park, c. 1946*

44. *Juniper Tree Detail, Sequoia National Park, c. 1927*

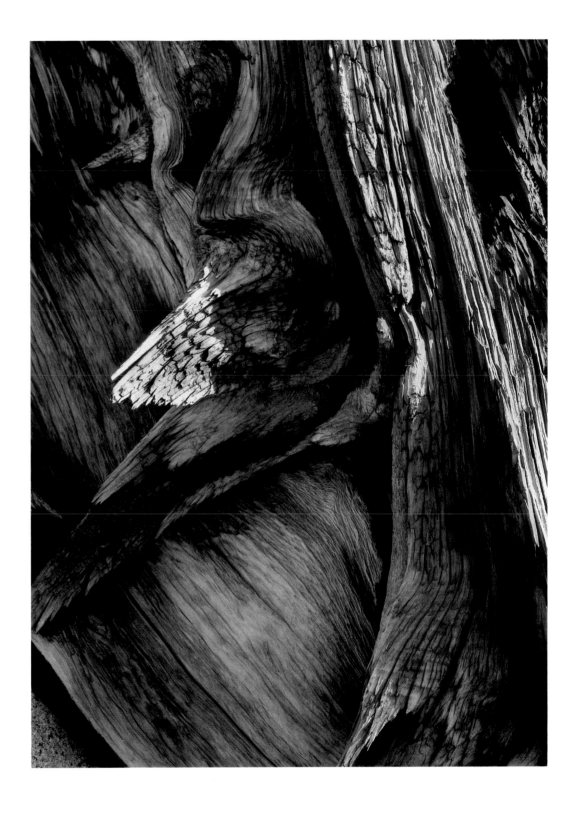

45. Grass and Pool, Sierra Nevada, c. 1935

46. Burnt Stump and New Grass, Sierra Nevada, c. 1935

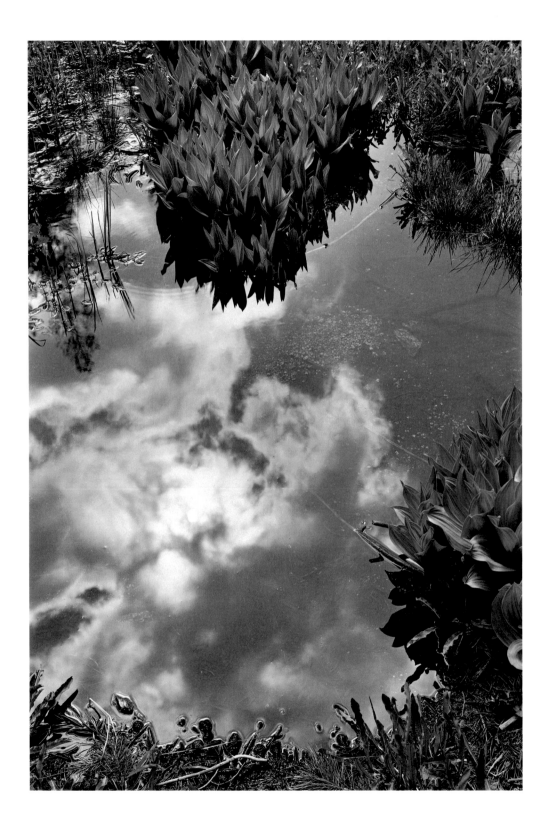

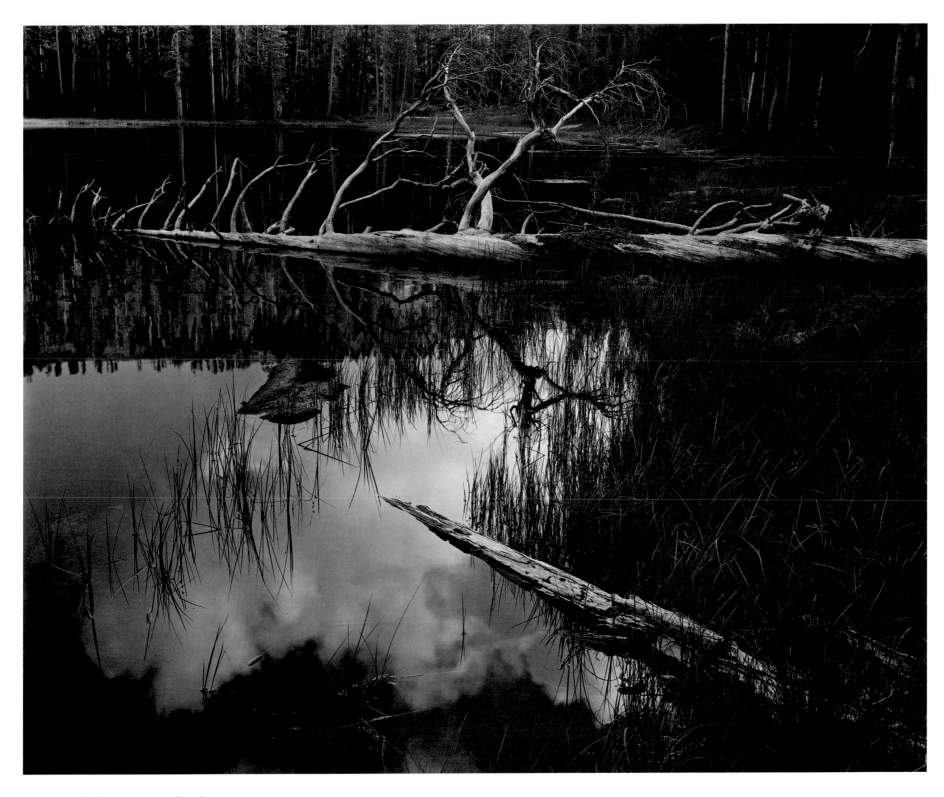

48. Siesta Lake, Yosemite National Park, c. 1958

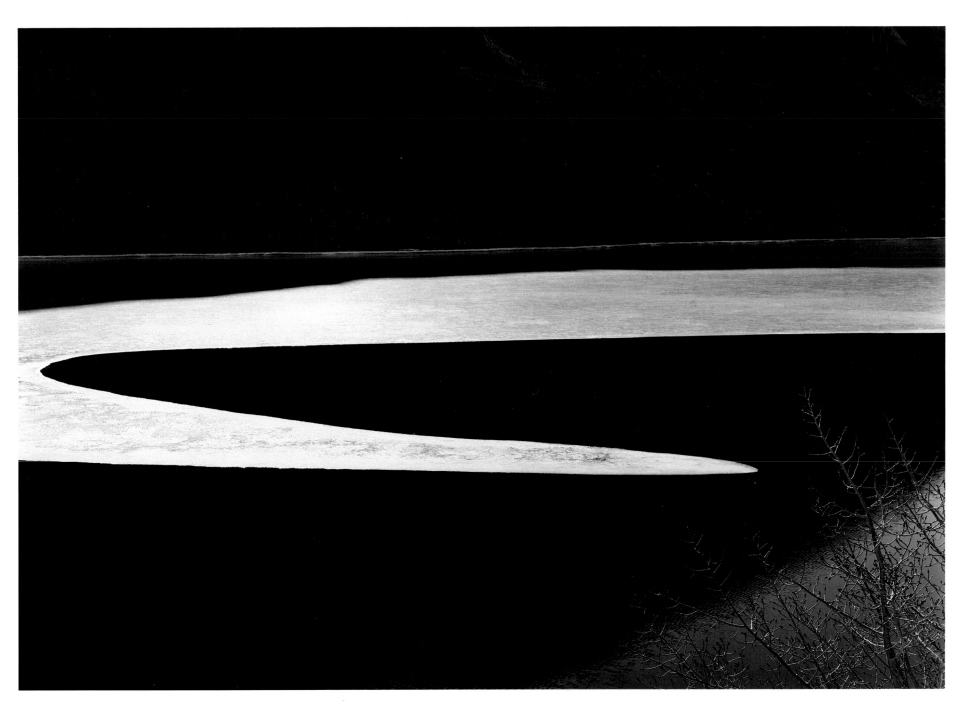

49. *Ice on Ellery Lake, Sierra Nevada, c. 1959*

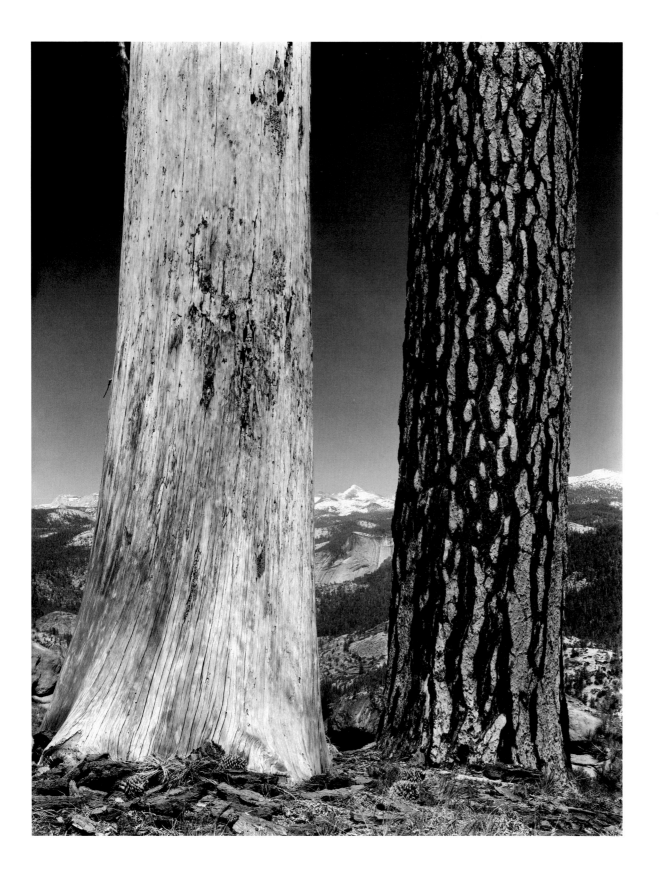

50. Trees, Illilouette Ridge, Yosemite National Park, c. 1945

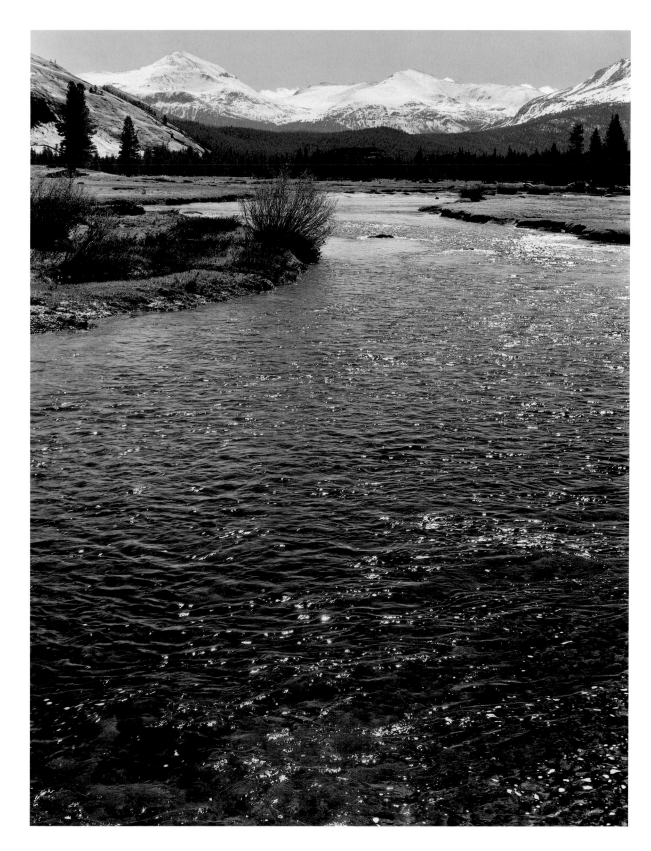

*51. Mount Dana and Mount Gibbs, the Tuolumne
River, Yosemite National Park, 1944*

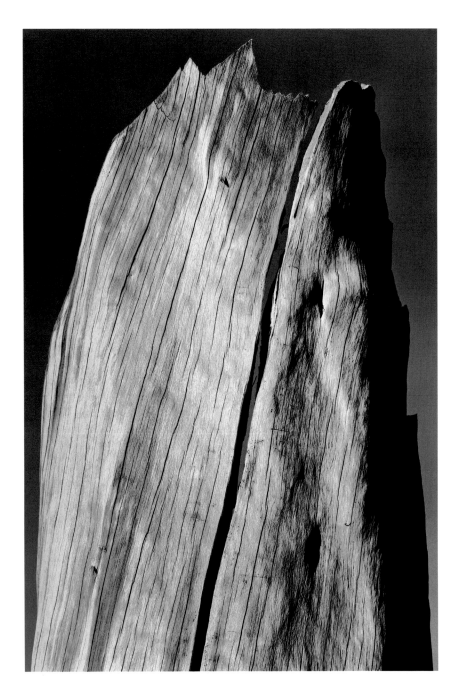

52. The White Stump, Yosemite National Park, 1936

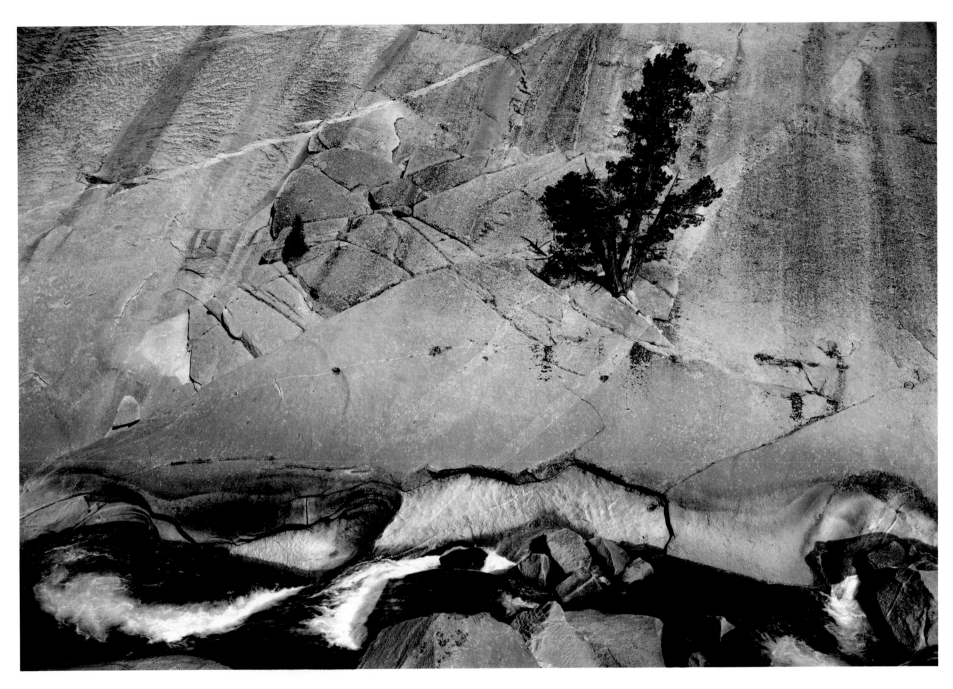

53. Juniper and Cliffs, Upper Merced River Canyon, Yosemite National Park, c. 1936

As I look back to earlier days, there were so few travelers in the Sierra that I began to feel a certain sense of "ownership"; they were *my* mountains and streams, and intruders were suspect.

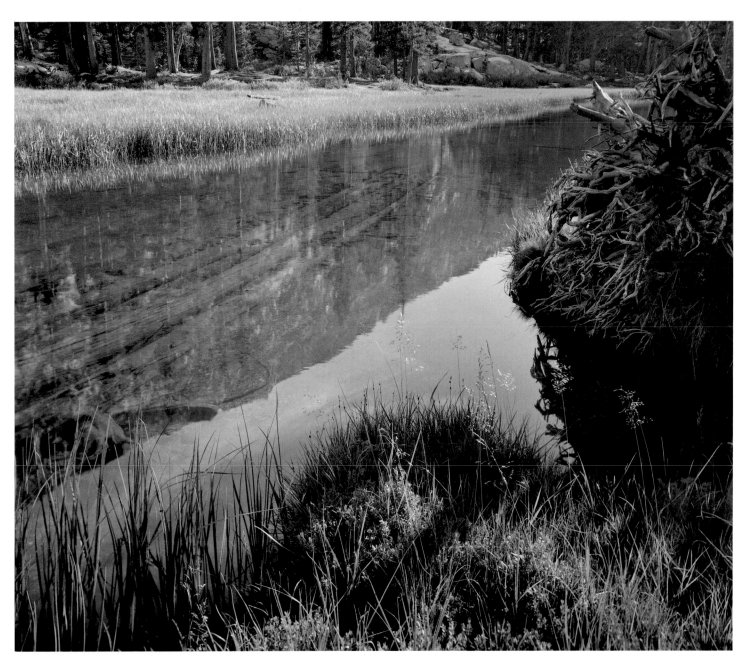

54. Meadow and Stream, Lyell Fork of the Merced River, Yosemite National Park, c. 1935

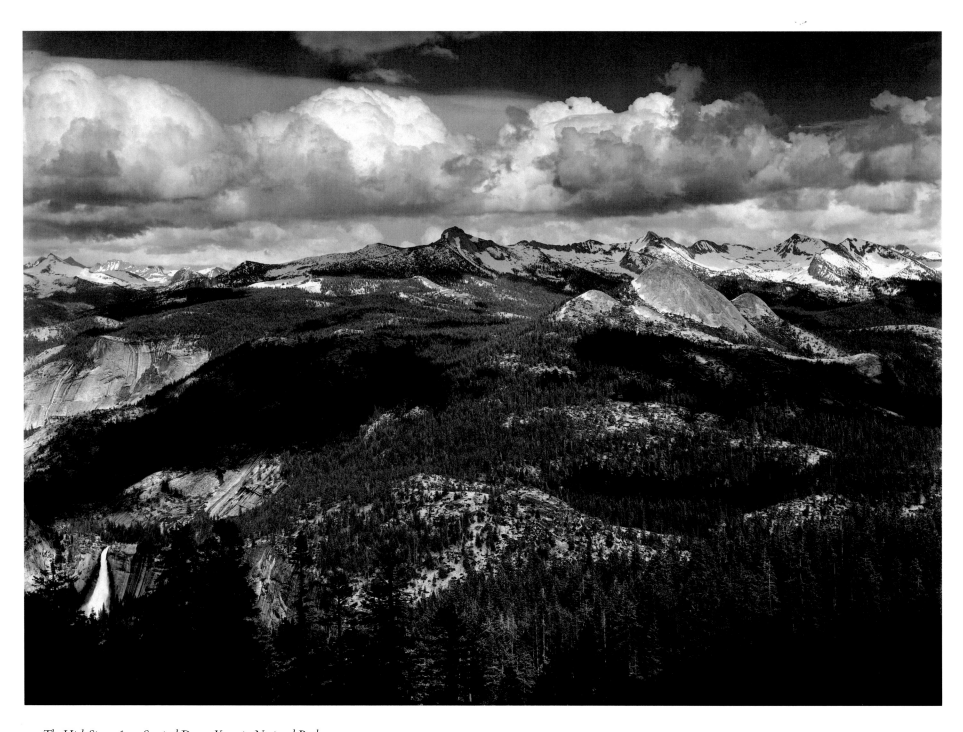

55. The High Sierra from Sentinel Dome, Yosemite National Park, c. 1935

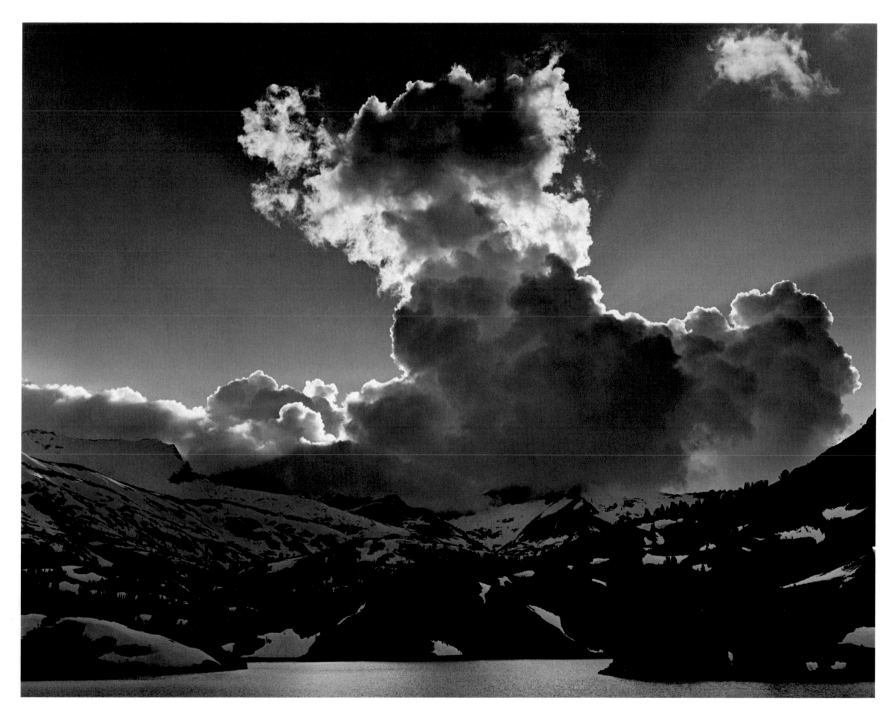

56. Evening Cloud, Ellery Lake, Sierra Nevada, 1934

It is easy to recount that I camped many times at Merced Lake, but it is difficult to explain the magic: to lie in a small recess of the granite matrix of the Sierra and watch the progress of dusk to night, the incredible brilliance of the stars, the waning of the glittering sky into dawn, and the following sunrise on the peaks and domes around me. And always that cool dawn wind that I believe to be the prime benediction of the Sierra. These qualities to which I still deeply respond were distilled into my pictures over the decades. I *knew* my destiny when I first experienced Yosemite.

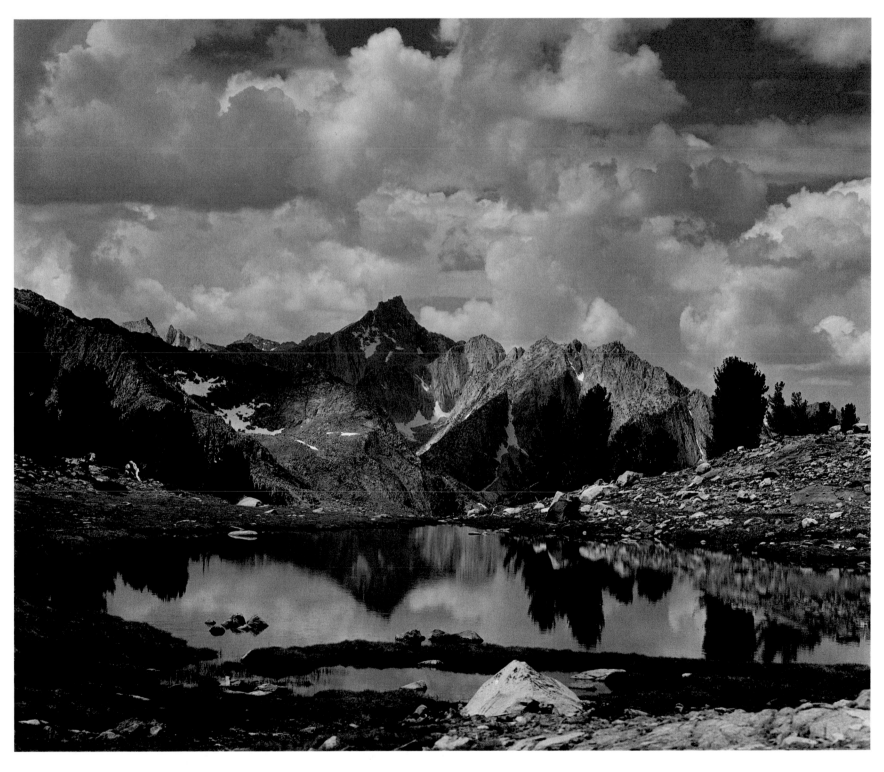

57. Mount Clarence King, Pool, Kings Canyon National Park, c. 1925

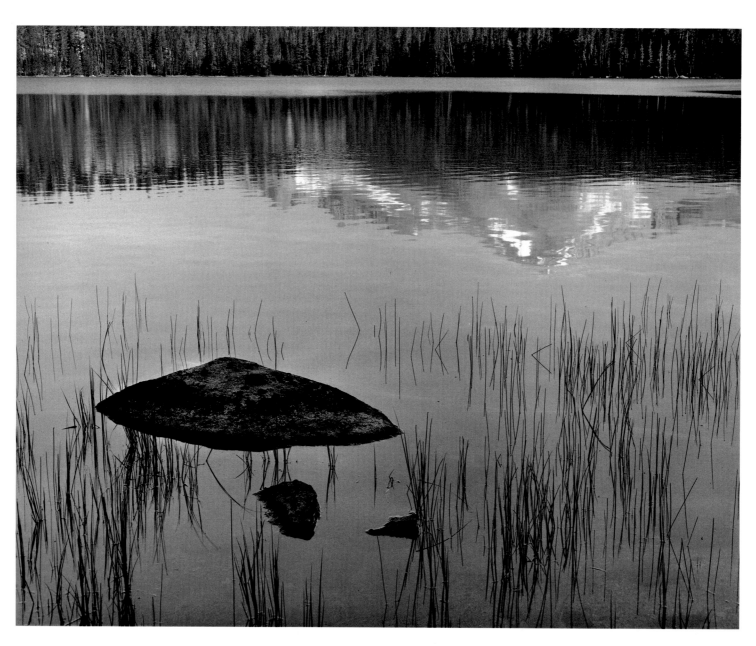

58. *Rock and Grass, Moraine Lake, Sequoia National Park, c. 1932*

59. *Big Bird Peak, Deadman Canyon,*
Kings Canyon National Park, c. 1934

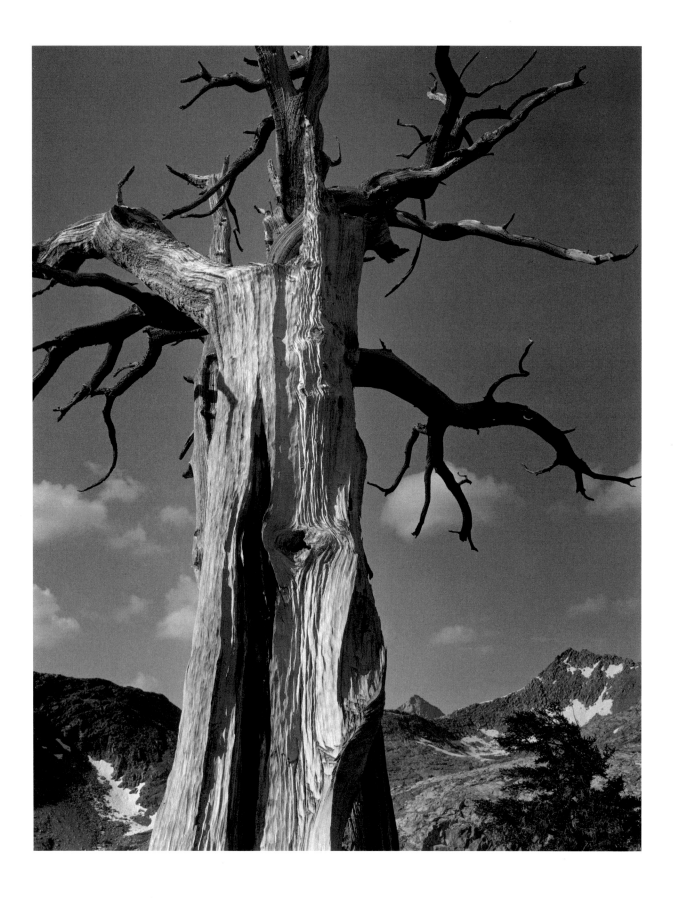

60. Dead Tree near Little Five Lakes,
Sequoia National Park, c. 1932

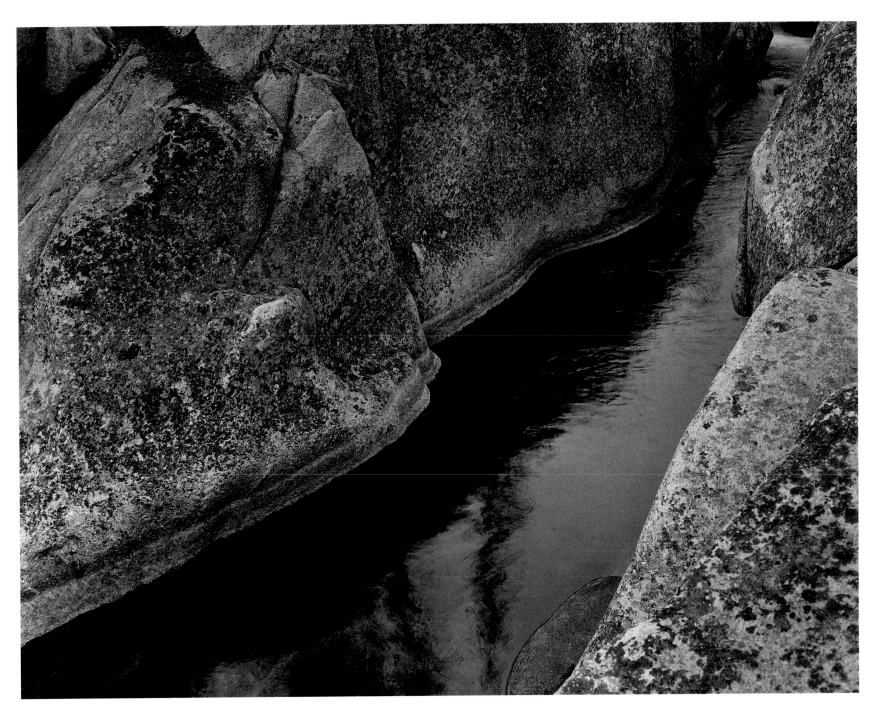

61. *Rock and Water, near Spiller Creek, Yosemite National Park, c. 1934*

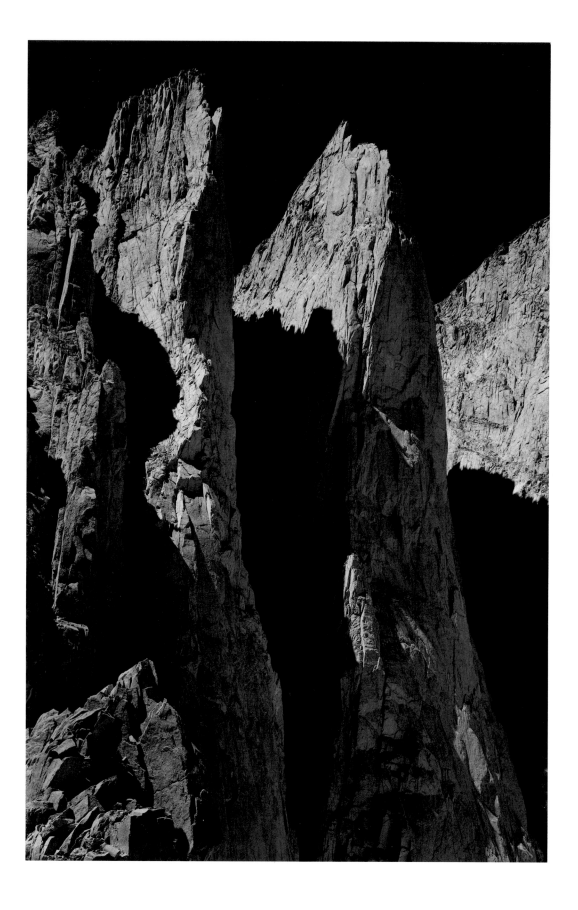

62. *Pinnacles, Mount Whitney, Sierra Nevada, c. 1940*

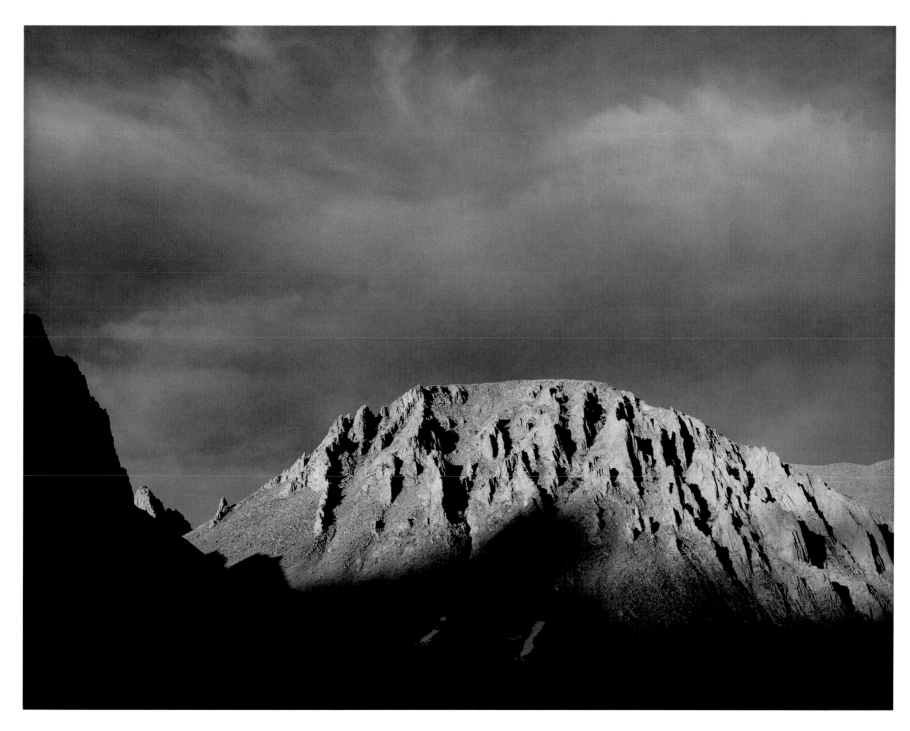

63. *West Slope of Mount Whitney, Sierra Nevada, c. 1932*

At dawn I crept from my bag into the cold Sierra air at seventy-five hundred feet elevation. A broad spur of granite touched the river nearby, and I decided to climb it, beckoned by the sunrise light on the sparse and rugged trees more than a thousand feet above me. As I ascended, the vistas of the Merced Canyon opened and I soon saw the crags below Mount Clark shining in the early light, their spires dominating all I could see. I returned to camp and found Uncle Frank busy with breakfast. He gave me a knowing smile and said, "Pretty fine, my boy, isn't it?" The mood of that moment was continued for many years and for many miles together on the trails and it was always pretty fine in every way.

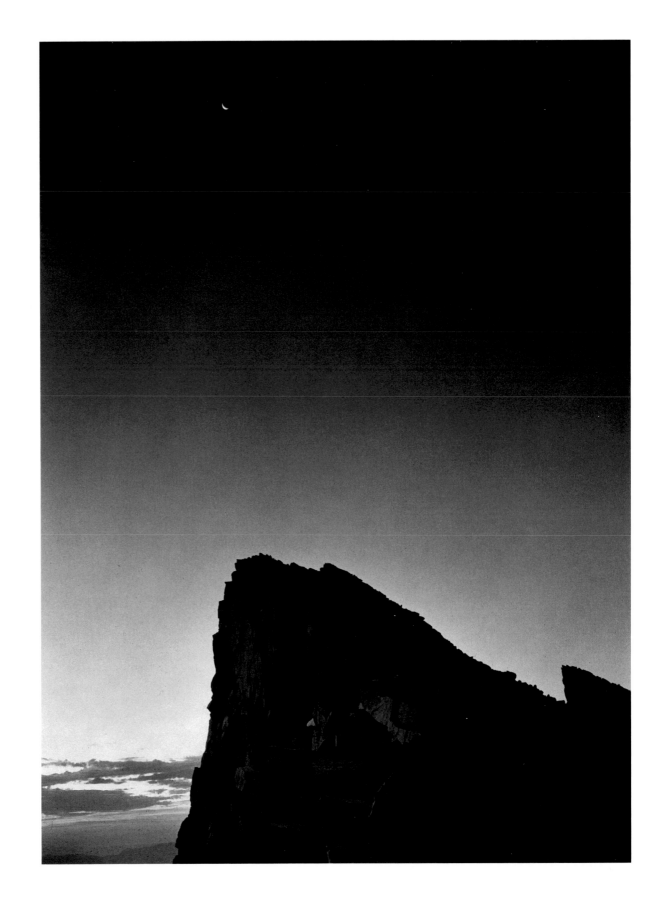

64. Dawn, Mount Whitney, Sierra Nevada, 1932

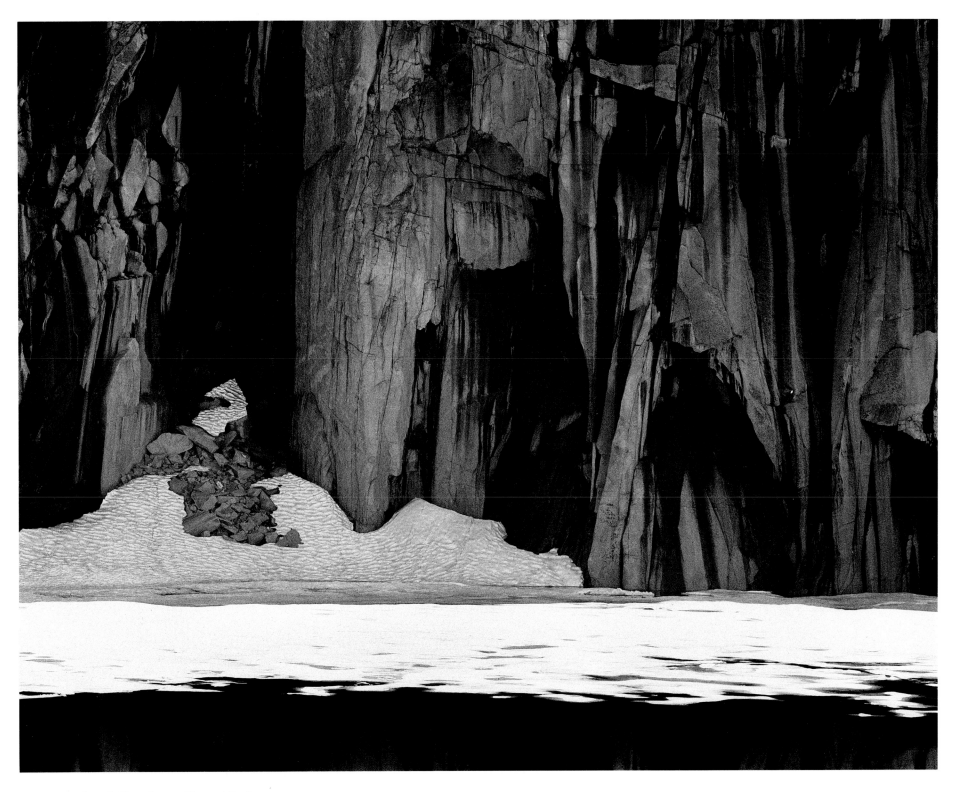

65. *Frozen Lake and Cliffs, Sequoia National Park, 1932*

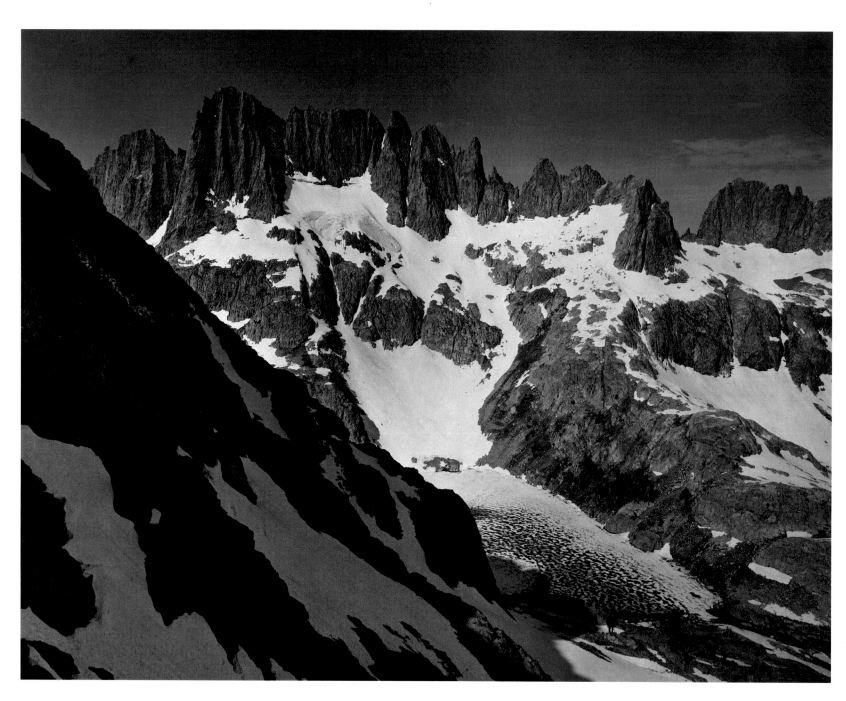

66. *The Minarets and Iceberg Lake from Volcanic Ridge, Sierra Nevada, c. 1935*

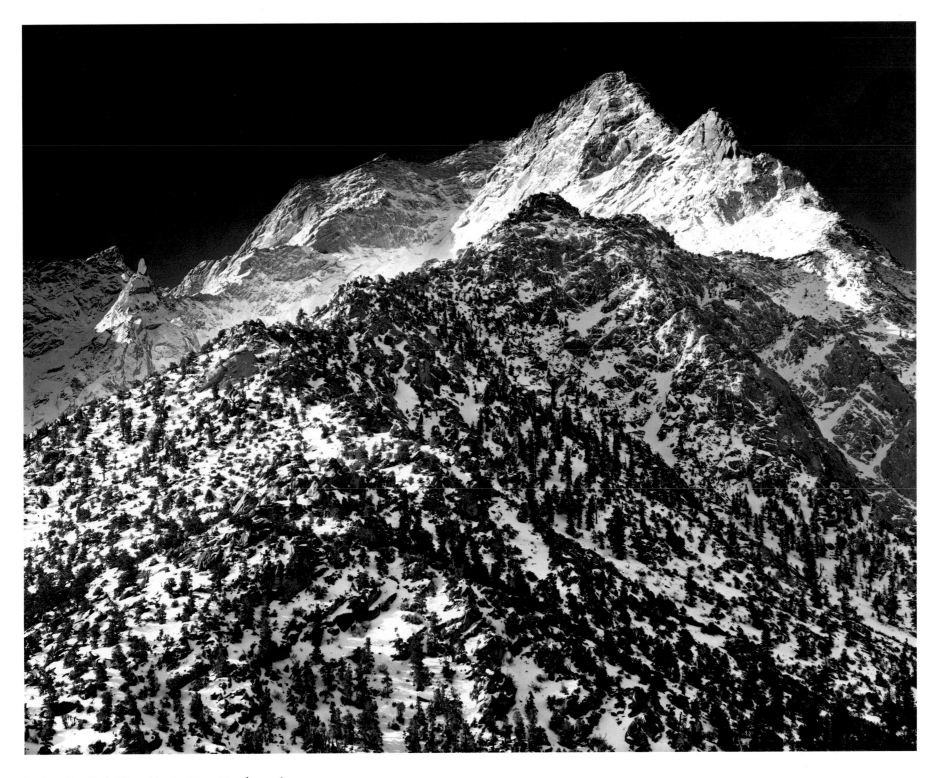

67. *Lone Pine Peak, Winter Sunrise, Sierra Nevada, 1948*

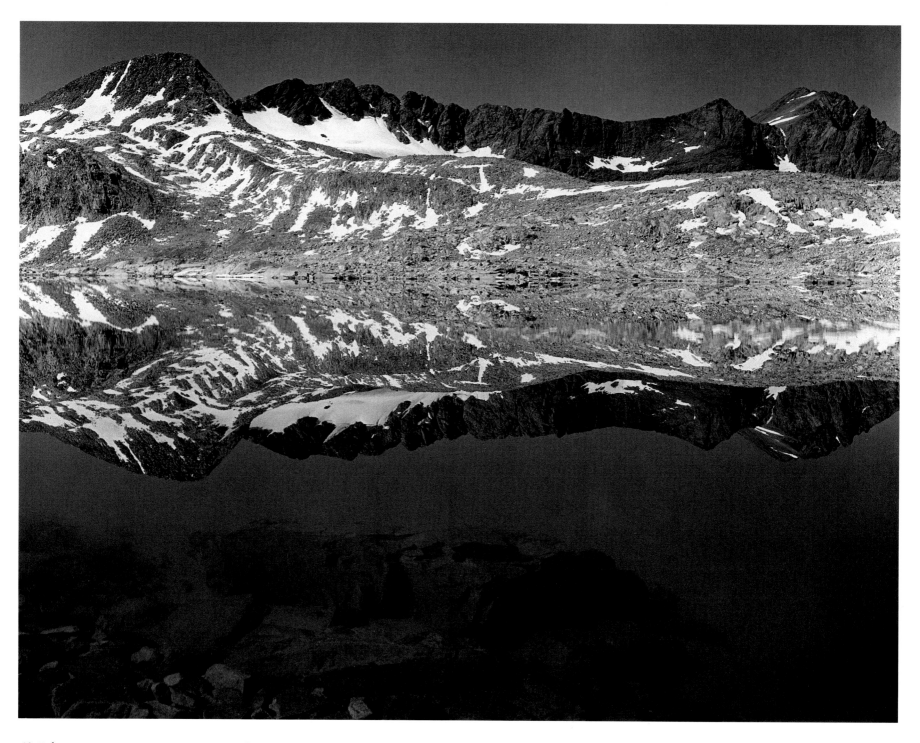

68. Lake near Muir Pass, Kings Canyon National Park, c. 1933

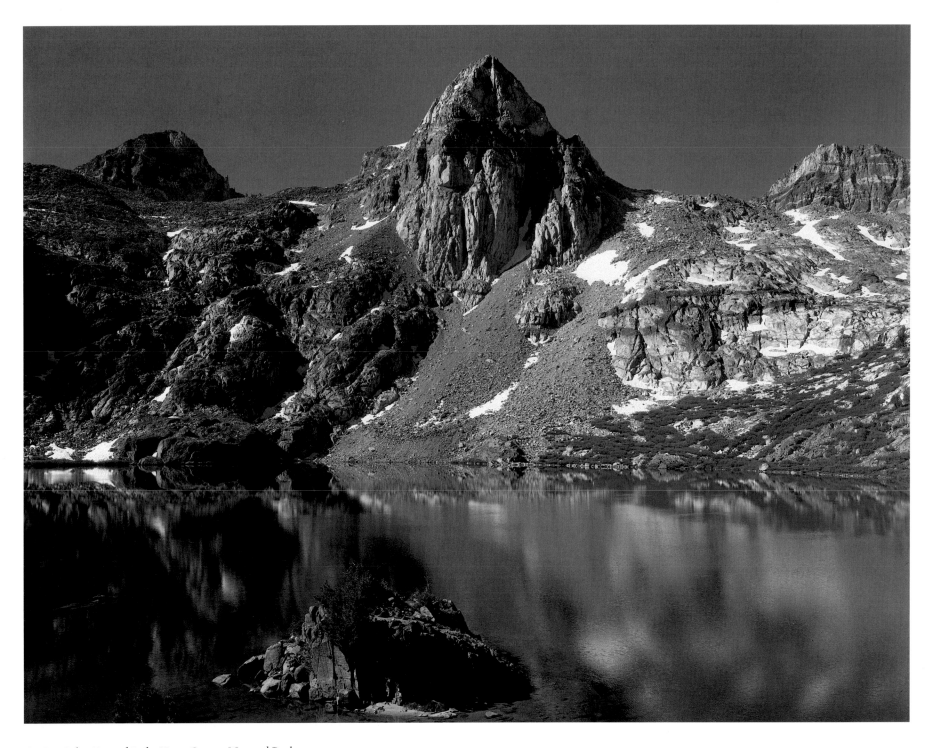

69. *Rae Lakes, Painted Lady, Kings Canyon National Park, c. 1932*

No matter how sophisticated you may be, a huge granite mountain cannot be denied—it speaks in silence to the very core of your being.

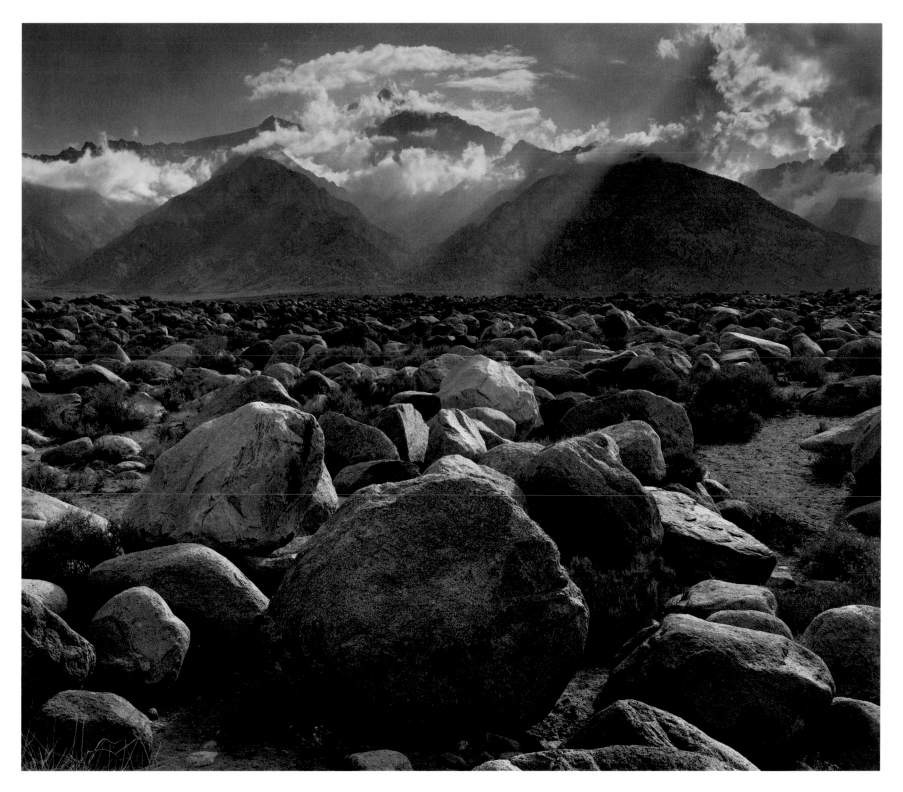

70. *Mount Williamson, Sierra Nevada, from Manzanar, 1945*

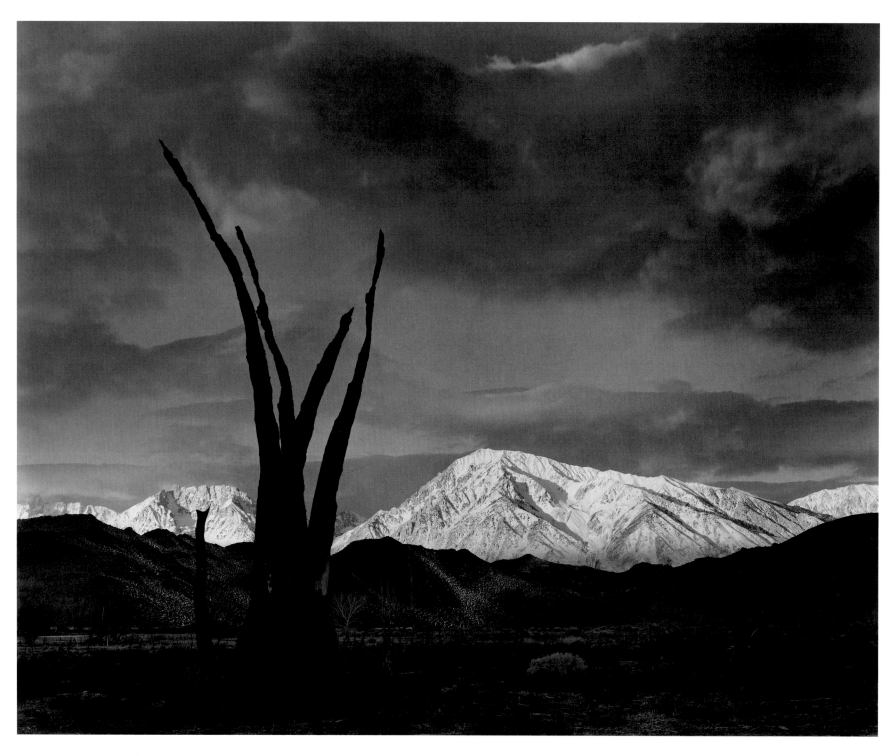

71. Sunrise, Mount Tom, Sierra Nevada, 1948

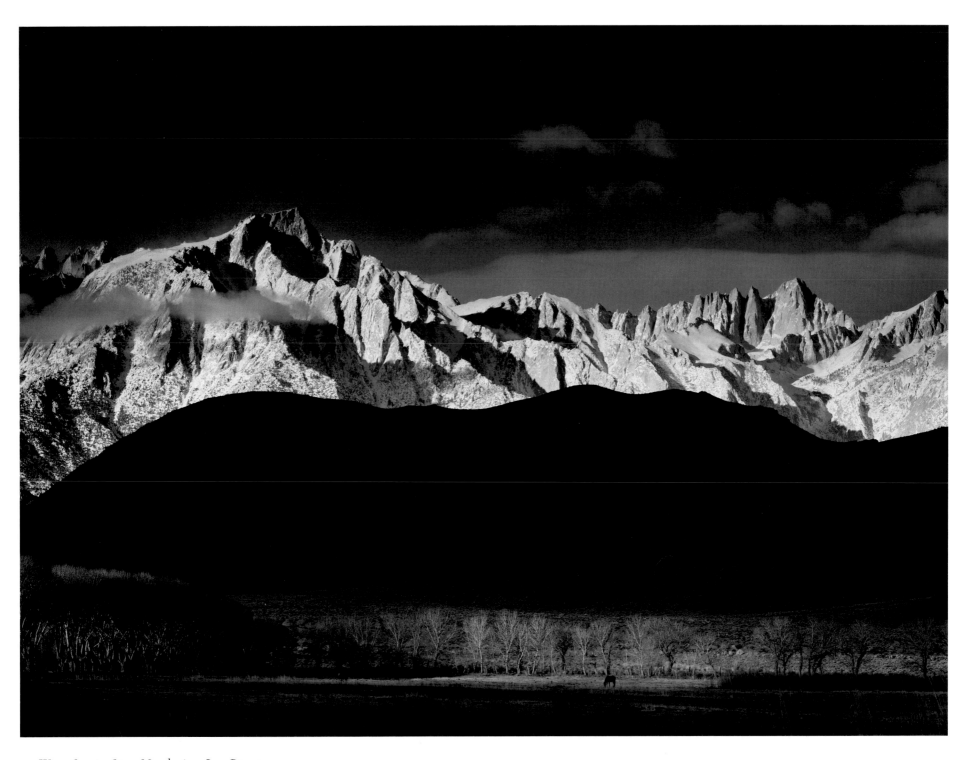

72. *Winter Sunrise, Sierra Nevada, from Lone Pine, 1944*

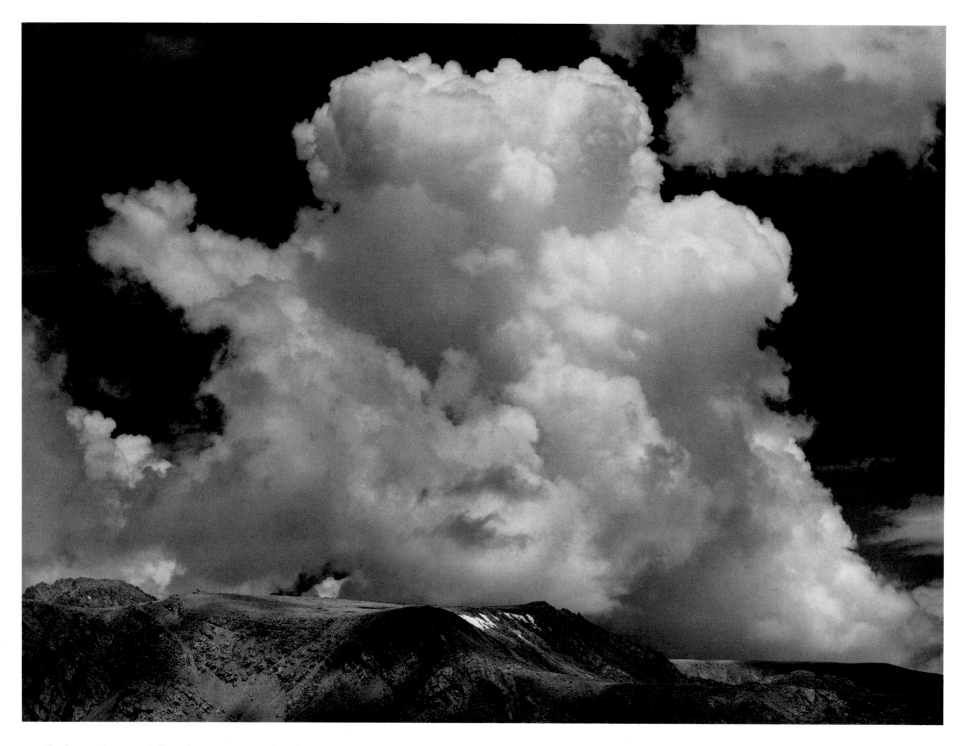

73. Clouds, view down Tyndall Creek, Sequoia National Park, c. 1932

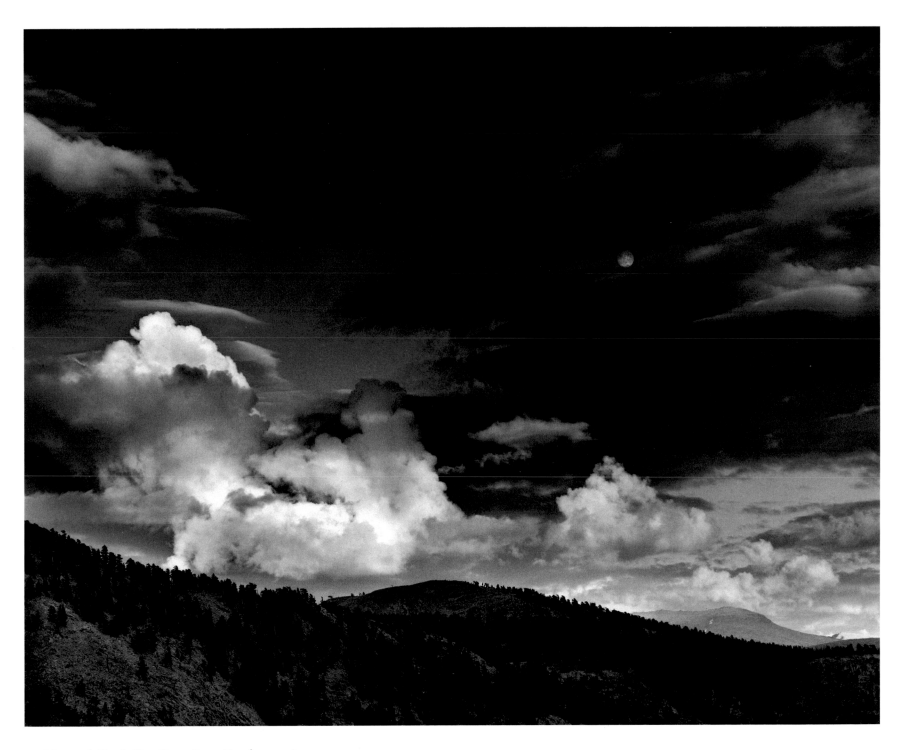

74. *Moon and Clouds, Kern Basin, Sierra Nevada, c. 1936*

Truly the "Range of Light," as John Muir defined it, the Sierra Nevada rises to the sun as a vast shining world of stone and snow and foaming waters, mellowed by the forests growing upon it and the clouds and storms that flow over it.

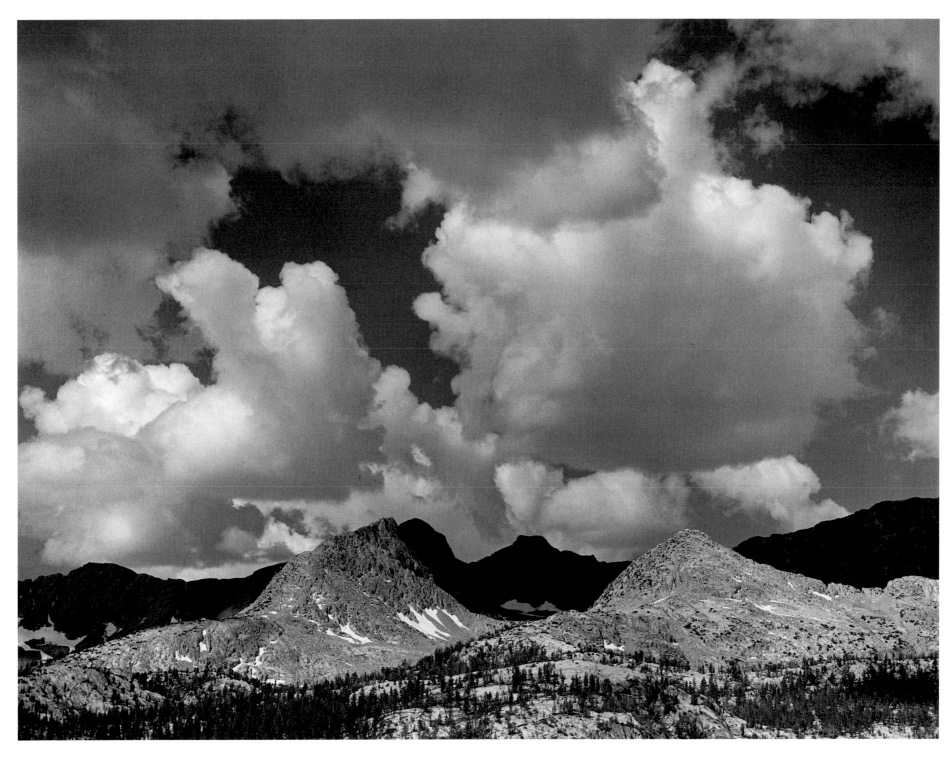

75. Emerald Peak, Kings Canyon National Park, c. 1933

Selected Writings on Yosemite and the High Sierra
by Ansel Adams

Fritsch rests his skis upright on a brittle arm of albicaulis. "We should wax now; it is a long run down to the lake." While we wait for our skis to warm in the sun we search the gleaming skyline for old landmarks and the peaks and cañons of new adventure. . . .

Just two days before we had thrilled on the extensive snowy summit of Mount Watkins overlooking Yosemite Valley, where we made mile-long runs with the gigantic forms of Clouds Rest and Half Dome rising before us across the abyss of Tenaya Cañon. Beyond these somber masses of sculptured granite, profoundly accentuated by heavy robes of snow, shimmered in white majesty the Merced Range—Mount Clark (the Gothic mountain), and the colorful shoulders of Red Peak. We skimmed the very brink of the great valley; four thousand feet below lay the white threads of roads, and a tiny rectangle of gray, dotted with almost invisible moving specks, which we knew as the large ice-rink in the shadow of Glacier Point. Beyond, steel-toned foothill ranges notched the long vistas of the San Joaquin plain. And against the western sky leaned the coastal mountains, unbelievably blue and far away.

This very morning, at the hour of silence and frosty stars, we were edging along the base of Tenaya Peak, our skis rasping and crunching on the brittle snow. Climbing around the western shoulder of the mountain, we came into full sunlight and a thrilling view of the main-crest peaks, white and cold in the early light. Here the snow was powdery and swift under our skis, but we refrained from downhill running and soon emerged on the summit—the hub of a tremendous wheel of mountain grandeur. A hundred miles of glittering peaks encircled our pinnacle of granite, and far below stretched the shadeless, dazzling plain of frozen Tenaya Lake.

The familiar and intimate aspects of the Sierra that one has learned to love during the long summer days are not obscured by winter snows. Rather the grand contours and profiles of the range are clarified and embellished under the white splendor; the mountains are possessed of a new majesty and peace. There is no sound of streams in the valleys; in place of the far-off sigh of waters is heard the thunder-roar of avalanches, and the wind makes only faint and brittle whisper through the snowy forests. To us, four motes on an

Earth-gesture of high stone, it appeared that great mountain spirits had assumed white robes of devotion and were standing in silence before the intense sun. . . .

Fritsch whips his skis on the snow and leaps down the long billowy slope; a cloud of powdery snow gleams in his wake. We follow; long spacious curves and direct plunges into the depths that take our breath with sheer speed and joy. Down and down through the crisp singing air, riding the white snow as birds ride on the wind, conscious of only free unhampered motion. Soon we are at the borders of icy Tenaya Lake—two thousand feet of altitude have vanished in a few moments of thrilling delight. . . .

Today we are moving on to Tuolumne Meadows. All the bright morning we were conscious of a deep stirring in the air, the world quickening to some obscure activity. Now, as we come upon the lower stretch of the meadows, we are aware of a remote, ominous sound, insistent as the murmur of a sea-shell pressed to the ear. Soon is this pulsing world-sound swelling to a deep and throbbing roar—the organ-tone of storm-wind sweeping the skies and mountains with immeasurable power. A huge dragon of cloud crawls out of the southwest, and with it comes a horde of gray demons, darkening the sun and veiling the summits. We arrive at our cabin under a leaden sky as the first snow is drifting down on the wind.

After several days, we emerge on a new and glorious environment, for the storm has piled a great splendor on the world, and peak and forest gleam with frosty beauty. The morning is clear and cold, the last stars burn with diamond light as we cross the meadows on our long run to Merced Cañon. The new day lifts over the silent range, Mount Conness takes sudden fire, blood-red and golden light flames on the long Sierra crest, and the crisp snow at our skis sparkles in the first sun. At Tuolumne Pass we find true alpine conditions—supremely fine snow, swift and dry; grand open areas above the last timber, undulating for miles under cobalt skies; peaks and crags flaunting long banners of wind-driven snow. A world of surpassing beauty, so perfect and intense that we cannot imagine the return of summer and the fading of the crystalline splendor encompassing our gaze.

The white magnificence yields to the clean motion of our skis, and we glide over the glistening dome of the world and launch our long descent to

the Merced River. Down we rush, cutting the sharp air with meteor motion; always the cool rushing wind, and the shrill hiss of skis upon snow. Above us towers the noble Merced Range, wave upon wave of lofty stone glittering in the low winter sun. A huge ledge lifts suddenly on the curved face of the hill; we turn in a bright mist of ski-spun snow and slant anew along the cañon wall. The mountains soar higher into the flaming sky, and the blue depths rise to enfold us as we skim down through the dusk to the shadowed valley with the swiftness known only to the ski.

Foreword to Sierra Nevada: The John Muir Trail
(Berkeley: Archetype Press, 1938)

Eastward, beyond the surf of the Pacific, beyond the tawny rolling Coast Range and the wide central valley of California, rises the great wall of the Sierra Nevada. Four hundred miles long, seventy-five miles wide, ten to more than fourteen thousand feet in height, it ranks with the major mountain ranges of the world. Certainly it is one of the most beautiful. Geologically, it is a tilted block of the earth's crust—a long, continuous slope fronting the west, and a short, breath-taking decline to the eastern deserts. The western slope is cut deeply with magnificent canyons forking back to the final peaks of the crest. Dominantly granitic, the rock has responded to the slow but irresistible wearing of the rivers and, later, to the refining sculpture and burnishing of the ice-age glaciers; the great forces of the earth have revealed a landscape of extraordinary purity and simplicity, vigor and grandeur.

Truly the "Range of Light," as John Muir defined it, the Sierra Nevada rises to the sun as a vast shining world of stone and snow and foaming waters, mellowed by the forests growing upon it and the clouds and storms that flow over it. White domes and ridges of granite merge with the black metamorphic rocks of the final summits; mineral-infused veins impose gleaming color on the peaks and canyons; hundreds of shining lakes are hidden in the stone matrix of the mountains. Snow fields scintillate above the last domain of growing things, and wide meadows, profuse with flowers, rest upon the gentler slopes and in the sheltered valleys.

So vast is the detail of the Sierra, so many aspects of the region demand adequate interpretation, that no one work of science or of art may compass it. It is one of the wonders of the natural world—a fresh and complete exposition of the forces of glaciation, of erosion by wind and waters, and of the deep travail of the earth.

As a region of recreation it is unequaled. In no other mountain range may be found a more benign climate, more favorable conditions for life out-of-doors, wider opportunities for the study and enjoyment of nature, more exciting temptations for the mountaineer. The ice-fields of the Alps and the Canadian Rockies are not found in the Sierra, but, as more than adequate compensation for this lack, there are clean high spires and summits of stone, crystalline sun and air, and the fragrance of lofty meadows and wild gardens.

For the artist and all others seeking the intimate splendors of the natural world the Sierra is an inexhaustible well of esthetic and spiritual stimulation. The interpretation of the Range has been mostly factual, but we may be sure that in time artists and poets, gifted in relating the qualities of nature to the mystical and creative elements in man, will seek in the remote fastness of the mountains the substance of their expression. The emotional interpretation of the Sierra Nevada—the revelation of the beauty of wide horizons and the tender perfection of detail—is the prime function of the present work.

The region concerned in this collection of photographs stretches from the Yosemite National Park in the north to the Sequoia National Park in the south, including the watersheds of the Tuolumne, Merced, San Joaquin, Kings, Kern, and Kaweah rivers, and the numerous streams descending the eastern slope. The John Muir Trail is the main artery through the Sierra, enabling the traveler to enjoy not only the rugged splendors of the crest, but also the more tranquil lower spurs and canyons and the magnificent desert-fronting regions of the Range.

A word about the photographs themselves: my best work with the camera in the Sierra, they attempt to convey the experiences and the moods derived from a close association with the mountains. Many of the important peaks and canyons are not represented—the sheer limit of space would restrict a complete exposition of this kind. No attempt is made to portray the Range in the manner of a catalogue; in fact, the program of the book determines that factual, informative qualities be submerged in favor of purely emotional

interpretative elements. A detail of a tree root, a segment of a rock, a great paean of thunder clouds,—all these relate with equal intensity to the portrayal of an impressive peak or canyon. The grandiose elements of the scene are subordinated to the more intimate aspects—for it is through the reception of beauty in detail that our experiences are formed and qualified. The majesty of form, the solidity of stone, the eternal qualities of the Sierra as a noble gesture of the earth, cannot be transcribed in any but the richest and most intense expression. Nevertheless, a certain objectivity must be maintained, a certain quality of reality adhered to, for these images— integrated through the camera—represent the most enduring and massive aspects of the world, and justify more than an abstract and esoteric interpretation. I feel secure in confining the tone-scale of my prints to a vibrant deep register and in adhering to a certain austerity throughout, in accentuating the acuteness of edge and texture, and in stylizing the severity, grandeur, and poignant minutiae of the mountains.

This work, then, is a transmission of emotional experience—personal, it is true, as any work of art must be,—but inclusive in the sense that others have enjoyed similar experiences so that they will understand this interpretation of the intimate and intense beauty of the Sierra Nevada.

Introduction to Yosemite and the High Sierra (Boston: Houghton Mifflin, 1948)

Fronting the arid lands of Inyo and Nevada on the east and sloping westward in massive folds of forested canyon and ridge to the Central Valley, the Sierra Nevada dominates California from the Tehachapi on the south (where the Sierra and the Coast Range join in a huge curve above the plain), to the volcanic peaks and lava flows of the Cascade mountains to the north. Midway in this enormous rise of land—four hundred miles and more in length—and directly east of San Francisco on the Diablo Meridian, lies the Yosemite Valley. Four thousand feet above the sea, the floor of this ice-sculpted canyon holds the most tranquil passages of the Merced River, which, with the larger Tuolumne to the north, drains nearly all of the twelve hundred square miles of mountains that form the Yosemite National Park.

At the age of fourteen I first came to Yosemite. It was for me a momentous experience. More responsive to wild environments than to urban, I had grown up around San Francisco, and knew the surf and dunes, the storms and fogs of the Golden Gate, the thickets of Lobos Creek and the grim headlands of Lands End. As a small child I had played in the crisp winter snow at Carson City, and seen the stately oaks of Atherton on the hot, brittle fields sweeping towards the San Mateo Hills and beyond to the madrone-lush folds of the Santa Cruz Mountains. A few months among the beaches and rain forests of Puget Sound had made indelible the scents of sea and spruce, tar and sawdust. Such early images are often as clear and compelling in memory as the actual vistas of today.

Plans for a family visit to Yosemite in the spring of 1916 stirred a new and great expectancy. A month before the great event I was given Hutchings' *In the Heart of the Sierra*, and pored over it, building fantasies of Indians and bears, of huge waterfalls and precipices, of stagecoaches creaking on the edge of catastrophe, of remoteness and magic. The known qualities of the sea merged with the unknown qualities of rivers and waterfalls, the redwoods of Santa Cruz with the Sequoia-gods of Wawona. The days became prisons of impatience and restlessness. Finally, the train at Oakland! All day long we rode, over the Coast Range, through Niles and Livermore, down across the heat-shimmering San Joaquin Valley, up through the even hotter foothills to the threshold of Yosemite. I can still feel the furnace blasts of air buffeting through the coaches, and hear the pounding, roaring exhaust of the locomotive re-echoing from the steep walls of the Merced Canyon. Then arrival at El Portal, and a night spent in an oven of a hotel, with the roar of the river beating through the sleepless hours until dawn. And finally, in the bright morning, the grand, dusty, jolting ride in an open motor bus up the deepening, greening gorge to Yosemite.

That first impression of the valley—white water, azaleas, cool fir caverns, tall pines and stolid oaks, cliffs rising to undreamed-of heights, the poignant sounds and smells of the Sierra, the whirling flourish of the stage stop at Camp Curry with its bewildering activities of porters, tourists, desk clerks, and mountain jays, and the dark green-bright mood of our tent—was a culmination of experience so intense as to be almost painful. From that day in 1916 my life has been colored and modulated by the great earth-gesture of

the Sierra. I have returned to it again and again, seeing in it countless manifestations of mood. For the past ten years Yosemite has been my home.

The conventional lines which delimit Yosemite on a map have no meaning on the high watershed ridges which are the geographic boundaries of the Park. In actuality, the spirit of Yosemite depends on an environment which extends to the Pacific and to the clear, bleak loneliness of the deserts beyond the Sierra crest. The basic rhythm of the land—the movement of hill and mountain forms, the power and tranquility of alternate wide valleys and soaring ranges—is revealed when the horizon is widened to include desert and ocean and the sky-notching crest of the Sierra Nevada.

Foreword to My Camera in Yosemite Valley *(Boston: Houghton Mifflin, and Yosemite National Park: Virginia Adams, 1949)*

The great rocks of Yosemite, expressing qualities of timeless, yet intimate grandeur, are the most compelling formations of their kind. We should not casually pass them by for they are the very heart of the earth speaking to us. Boldly advancing from the matrix of the mountains, towering thousands of feet into the sky from the green edge of the Valley floor, they dwarf every conceivable structure of man. Indeed, there are higher mountains, vaster ranges, deeper canyons, but nowhere except in Yosemite are cliffs that rise with such clean dignity, such vigorous sculpture, and such firm substance as possessed by these colossi of the Sierra.

The dominant rock forms of the Valley are not isolated mountains rising from an undulating plain; they are the exceptional expressions of a uniformly high rim. The Yosemite Valley is a deep cleft in an extensive mountain uplift. Hence the great rocks while standing out boldly with impressive power are linked by continuous and scarcely less interesting slopes and precipices of equivalent and even greater height. Half Dome is an exception; it marks the end of a great ridge dividing the canyons of the Merced River and Tenaya Creek.

Eloquent of tremendous geologic progressions, and but little changed since the recession of the last glaciers, each great rock is distinctive in form and surface. El Capitan exhibits 3000 feet of compact and brilliant granite, cream-gray and shining in the Sierra sun. The vast 2000-foot sheer cliff of Half Dome, rising from a 3000-foot base and facing the north, is equally compact and vigorous but darkened by lichen and shadow. Slight variations in granitic structure alter the color and texture of the rocks less than conditions of exposure; the cliffs facing south are brighter, sun-clean; while those facing north assume more severe and solemn tonalities.

The great rocks are usually observed from but a few popular viewpoints; each is known by conventional presentation of many years' description and picturing. Yet the rocks reveal numberless aspects—not only of position, but of hour, weather, and mood. You cannot say you have known them until you have seen them in sun and shade, watched the cloud shadows flow across them, or the clouds congeal around them. You must know them in the severity of dawn, in blazing noon, and in the nostalgic afterglow of dusk. Firm and everlasting as they appear by day, the rocks acquire a special magic by moonlight—they become vast as the earth itself and of glowing volatile substance and form.

The majestic forests of the Sierra are especially impressive in the Yosemite region; from the groves of Sugar Pine north of the Valley, through the Yellow Pine and Fir belts of the Valley floor and its surrounding heights, to the giant Sequoias of the Mariposa Grove to the south, we pass through a continuous green canopy redolent with sun and wind, and throbbing with wilderness life. Massive forests crowd to the very edge of the rim and overflow down the steep gorges, striving to meet the forests on the Valley floor that reach high against the sheer stone. On granite ledges and the steepest slopes, oak and manzanita struggle for security and precious root-holds. Sedges and grasses climb where larger vegetation capitulates, and moss and lichen creep with security where no other life could persist. In the benign seasons, flowers grow everywhere, even clustering on the traces of soil among the most rugged crags. So balanced is the fecundity of Nature here that seldom are the weakest growing things denied their modicum of light and air and their dignity of existence.

The waterfalls of Yosemite can be explained geologically, defined in terms of height and volume, pictured and described as great natural curiosities—all of which may evade the deeper qualities of their beauty. Anyone who has seen the great falls of Yosemite thundering in the floods of Spring, leaping

alive with down-thrusts of white rockets, and rolling clouds of white mist from their shattering bases, must accept them as something more than a mere physical inevitability of Nature.

A waterfall is but an episode in the life of a whole singing stream, pouring from the high stone fountains of the summit peaks to the blending with the greater river below. We can trace its exuberant life from glittering fields of ice and snow, through clean alpine meadows, the clear pools, cascades, and the flowery groves of the high country, and the longer passage through the timbered valley to the rim of Yosemite. Then suddenly the prodigious leap—and the frothy gathering in the tranquil reaches on the Valley floor.

Each waterfall retains its basic character at all times of flow. Massive in Spring, they become more delicate as the season progresses. Some dry up and rest altogether through the Autumn. Others keep a token flow throughout the year. Bridalveil Fall, even in highest flood, retains a mood of delicacy. Nevada Fall thunders with Thor-like severity. Vernal Fall is always formal and decorative, and Illilouette Fall tosses its white plumes at the far end of a rugged canyon. The Yosemite Fall expresses a daring jubilancy—a leaping, pounding force in early Spring, a swaying, floating wraith in late Summer. In Winter ice forms nightly on its huge cliff and at the touch of sun falls booming and echoing to the rocks below.

In addition to the five major falls there are many lesser though equally beautiful cascades—each expressing an individual relationship of water and stone, each developing its vital patterns of descent and impact. You will see how the Royal Arch Fall defines the exquisite lines of its granite cliff, churning in age-old grooves and fanning out in glittering lace on the smooth bosses of stone; and how the Sentinel Fall pours down in a crescendo of increasingly high leaps to the Valley floor; and how Piwyack Fall in the upper Tenaya Canyon (seen from Glacier Point) races down a thousand feet of steep granite, dwarfed only by the tremendous barren grandeur of its environment. Ribbon Fall, west of El Capitan, fills its deep-etched rock cleft with 1700 feet of feathery thunders. In early Spring a little stream pours over the east shoulder of El Capitan. Caught by the wind it dissipates in prismatic spray, but the moisture is coalesced at the base of the sheer cliff and gurgles down through oak and talus to the meadows below.

Do not be content to stop at the popular viewpoints: walk in the cool forests and by the river and streams, and watch the great rocks and waterfalls reveal themselves in endless and varied character. Their height and mass exceed most things in our normal experience. Hence, in themselves, they at first may appear somewhat incomprehensible. Yet if we become aware of the expressive minutiae of their structure, and of the myriad intimacies of the forests and riverbanks and meadows of the Valley floor, and if we try to merge the enormous and the minute into one vibrant unity—the spirit and beauty of Yosemite will grow upon us. You will find this experience best in a few hours of solitude away from the roads and the service centers of the Park. It will come to you in the forest and by the river, or on the trails that thread the heights and lead to the thrilling vistas from the rim and to the beautiful uplands of the Park.

The great rocks and the falls, the magnificent forests and the infinite minutiae of Nature, the storms and the clouds, the flowers and living things of earth and air—all are awaiting you and your camera in Yosemite.

Foreword to "Portfolio III: Yosemite Valley," 1960, a limited edition portfolio of sixteen original photographs

Yosemite Valley, to me, is always a sunrise, a glitter of green and golden wonder in a vast edifice of stone and space. I know of no sculpture, painting, or music that exceeds the compelling spiritual command of the soaring shape of granite cliff and dome, of patina of light on rock and forest, and of the thunder and whispering of the falling, flowing waters. At first the colossal aspect may dominate; then we perceive and respond to the delicate and persuasive complex of nature.

After the initial excitement we begin to sense the need to share the living realities of this miraculous place. We may resent the intrusion of urban superficialities. We may be filled with regret that so much has happened to despoil, but we can also respond to the challenge to re-create, to protect, to re-interpret the enduring essence of Yosemite, to re-establish it as a sanctuary from the turmoil of the time.

How may we accomplish this?

Who can define the moods of the wild places, the meaning of nature in domains beyond those of material use? Here are worlds of experience beyond the world of the aggressive man, beyond history, and beyond science. The moods and qualities of nature and the revelations of great art are equally difficult to define; we can grasp them only in the depths of our perceptive spirit.

Perhaps age must remember the clear perceptions of youth and return to the sensing of freshness, of strength, and of wonder; perhaps age needs to recall the beginnings of comprehension of mood and meaning and to rekindle an appreciation of the marvelous, of being in resonance with the world. If a man nurtures his sensitive awareness of the natural world with experience and contemplation, his spirit will remain young. . . .

Both the grand and the intimate aspects of nature can be revealed in the expressive photograph. Both can stir enduring affirmations and discoveries, and can surely help the spectator in his search for identification with the vast world of natural beauty and wonder surrounding him—and help him comprehend man's continuing need for that world.

Excerpt from an oral history for the Bancroft Library, University of California, July 1972

I remember my first trip in the high country. Mr. Holman and Miss Smith and Admiral Pond and his daughter Bessie and two donkeys—we left Yosemite and went up to Merced Lake Trail. Went all the way to Merced Lake. I was absolutely exhausted. It was raining. We'd just get tantalizing glimpses of mountains. The first time I'd ever slept out on the ground. And Bessie Pond and the Admiral were very kind to me, and they showed me how to fix the bed and cut off some pine boughs to sleep on which you wouldn't think of doing today. (That would be terrible.) That was the way we made beds. There were plenty of plants and trees around.

And then it rained a little that night, and I remember rivulets going in the sleeping bag down my neck. And then it cleared up, and I remember Bessie Pond and Admiral Pond—we were all lying out on this meadow. And Bessie said, "Oh, look at the stars!" and that was the first time I'd ever seen stars so

absolutely bright. This was at seven thousand feet. And that again was a primal experience. It was just an amazing thing.

And then in the morning at dawn I got up and along with everybody else, climbed up a long tongue of granite on the north. And at sunrise we saw [that] the big crags under Mount Clark (which are really not big at all) looked very spectacular in the sunrise light. And the absolutely pure air and clean dawn wind and the glowing sunrise on these warm-toned peaks, and the sound of the river and the waterfall—the whole thing created an impact which was quite overpowering. I've never been able to put that particular experience in a photograph because it was so complex in so many ways. I don't know if I'm making sense with this. But this was the very first great High Sierra experience. That whole trip was just one fine experience after another. That was 1917.

Foreword to Ansel Adams: Yosemite and the Range of Light *(Boston: New York Graphic Society, 1979)*

Since June 1916 the Sierra has dominated my mind, art and spirit. It is quite impossible to explain in words this almost symbiotic relationship. My photographs must serve as the equivalents of my experiences, and I hope they may help others to express their own experiences in whatever medium they choose. All art is a vision penetrating the illusions of reality, and photography is one form of this vision and revelation.

The Sierra Nevada, so aptly called the "Range of Light" by John Muir, rises as a great wave of stone for four hundred miles between the arid wastes of the Great Basin and the verdant Central Valley of California. In the billowing western slopes are many valleys and canyons, carved first by the forces of water and then configured by great rivers of ice during several glacial ages. The grinding ice moved from the summits down to elevations of two to four thousand feet. The geologic history of the Sierra is ancient and complex, and scientists are still pondering the uplifts, the faults and the patterns of erosion of this vast, tilted block of the earth's surface.

Those who have seen the great uplifts of the Himalayas, the Andes, the Alps and the Alaskan ranges may not think of the Sierra Nevada as *mountains*.

They have neither formidable rivers of ice nor skies cut with forbidding towers of rock. I think of the Sierra as sculptures in stone, rather delicate and gentle, yet not small! The canyons reach seven thousand feet in depth, and the eastern face of the range rises more than ten thousand feet above the Owens Valley. The juxtaposition of rock, glacial lakes, meadows, forests and streams is extraordinary. It is the *detail* of the Sierra that captures the eye and entices the camera. One wanders in open forests and wild gardens of infinite variety studded by boulders of whitish granitic or lichened metamorphic. Spring follows the elevations from the low, rolling foothills; at eleven or twelve thousand feet September flowers will bloom in the crevices of the clean and shining summits. No mountain is so large that you cannot climb from its immediate base and descend in a day.

Spectacular thunderstorms of summer pile ten-mile-high white billows into the sky; thunder reverberates from the granite walls and basins with the metallic roar of great gongs. John Muir said it never rains in the Sierra at night, and it seldom does. At dawn the high meadows may be white with frost. There is a purity and clarity of air through which the stars seem very close, and the dawn wind makes the forests and crags coolly and gently vocal.

Yosemite Valley is a small but supremely impressive section of the Merced River complex. In the valley, the Merced represents the joining of many tributaries, flowing from sources in the highest summits, the cirques, glacial lakes and meadows of what we call the High Sierra of the Merced watershed. North of the Merced flows the Tuolumne River, larger in resource and power. South lies the largest river system, the San Joaquin. And farther south are even loftier source regions of the Kings, Kaweah, and Kern rivers—all flowing down to the Central Valley, and, in earlier times, all but the last-named streams to the bay of San Francisco and the Pacific Ocean. Irrigation and urban demands now leave little water to complete the journey to the sea. The waters of Lake Tahoe at the northern end of the Sierra Nevada flow down the Walker River to the eastern desert. . . .

I came to Yosemite for the first time in 1916, at the age of fourteen, and for me it was a tremendous event. My first impressions were of monuments of great height, stately sculptures of stone glowing in searching sun, white waters pouring in thunder from the cliffs, and a sky active with clouds. The Merced was in full spring flood; rapids, deep pools, facades and grottos of forest, and light everywhere.

Through 1924 I explored almost every accessible feature of Yosemite Valley and the adjacent High Sierra. In 1925 and 1926 I made extensive trips into the Kings River Sierra with the Joseph Le Conte family. Then, in 1927, I made my first High Trip with the Sierra Club into the Kaweah and Kern Sierra. In 1929 and after, I made many trips with the Club, serving as assistant manager of their month-long outings, hiking and climbing with my cameras, helping set up the camps, organizing the mountaineering programs, managing the evening campfires and seeking lost people. The day usually ended loading plates or films in their holder using a photographic changing bag or lying head down in a stifling sleeping bag. This very hectic program was repeated for about five years with the Sierra Club. At other times I would explore many remote areas, including the east side of the Sierra, which dips to the desolate but beautiful Owens Valley, and I would also wander about the Alabama and Tungsten Hills, remnants of ancient Sierra ranges composed of a marvelous chaos of weathered granitic rocks. Every year since 1916 has found me in some part of the Sierra Nevada. It has truly been a lifetime of close contact and great experiences with nature.

Since 1919, when I joined the Sierra Club, I was seriously involved with the conservation movement. From 1919 to 1924 I was summer custodian of the Sierra Club's Le Conte Memorial in Yosemite Valley. I passed through the messianic period, battling the implacable devourers and mutilators of wilderness, and gradually I entered a more philosophic-humanistic stage where I was able, in some small way, to separate personal euphoria from impersonal appraisals of the rights of man to participate in the bounties of his environment. The fact that he has fouled his nest and seems certain to continue with his destruction seems now more of an illness than an expression of evil intent. The problem is not *whether* we must save the natural scene, but *how* we may accomplish it.

As I look back to earlier days, there were so few travelers in the Sierra that I began to feel a certain sense of "ownership"; they were *my* mountains and streams, and intruders were suspect. I got over that distortion of reality quite early, but I can still recall the wondrous experience of wandering for days completely alone (except, perhaps, for my donkey). There was only an

occasional small vagrant plane in the sky; there were no radios or rescue helicopters, and no contrails lacing the dome of heaven. The trails were mostly primitive, and the maps not too accurate. But all the streams and lakes were pure, the air was crystalline except when some distant forest fire put an amethyst veil over the mountains. I cooked over an open fire, my grate was a little Stonehenge of rocks on which blackened tin cans (with wires for grasping) teetered with sometimes disastrous results. A warped frying pan and a small bucket completed the regal equipment. Salt, bacon, tinned butter, flour, rice, coffee, dried or condensed canned milk, bars of chocolate, dried fruit and a can or two of Log Cabin syrup filled one kyack of my pack; the other was reserved for simple utensils, cameras, and film. An old-fashioned sleeping bag and a sheet of canvas were lashed across the top of the pack. I had no air mattress; such was considered effete. I would sleep on some gathered branches or pine needles, sometimes on bare glacial rock. In some way my body molded its way through a thin blanket to the contours of the stone, and I slept in blissful, comparative comfort.

It frightens me now to think of many of the ascents I made during those times. I had no idea of the techniques of climbing, but in some way I survived. My old friend Francis Holman and I made really hazardous scrambles tied together with a window-sash cord. We did not know the real meaning of a belay and often climbed in unison; if one had slipped and fallen, the other would inevitably have been dragged along to disaster. We would be drummed out of the mountaineering fraternity if we tried any such adventure now. Yet the advanced climbers of today, while they perform miracles of vertical virtuosity, may have created with their pitons and expansion-bolt drilling more damage to the cliffs than ten thousand years of natural erosion. Our early climbing experiences left no trace whatever. But the most dedicated and gentle human feet, if there are enough of them, will wear down the sternest stone, strangle the near-surface roots of the giant sequoias, and flatten meadows into hardened promenades. The preservation and, at the same time, the human use of wild places present a mind- and spirit-wracking challenge for the future.

I am an ardent believer in wilderness, which reflects the mystique of nature, and I have enjoyed both companionship and solitude in the high mountains. From the beginning I was impressed by the philosophy that all life and art are justified by communication; experiences are to share, not to hoard. In earlier days the Sierra Club Annual Outings brought hundreds of people a year into the Sierra to give them memorable experiences and to influence them to work for preservation of wild places. Ironically our citizens have responded with encouraging unanimity, and now overpowering numbers of wilderness worshipers come to the high altars and sacred groves.

William E. Colby, the great conservationist and leader of the Sierra Club, told me that around 1910 when he and John Muir were at Glacier Point above Yosemite Valley Muir said, "Bill, won't it be wonderful when a million people can see what we are seeing now!" Many millions have experienced this noble view since 1910; the great domes and distant summit peaks have not visibly changed, and, as Edward Carpenter wrote, the forests continue to flow over the land as cloud shadows. No evidence of man can be seen, except on the floor of Yosemite Valley, and this promises to be reduced within practical limits in the coming years. Establishment of the Parks and Wilderness Areas has secured the integrity of vast domains of natural beauty. I hope that those entrusted with the administration of these areas will ever be alert to the constant and increasing pressures for many forms of exploitation. The problem is one of balance between highly restrictive preservation and the concept of appropriate use.

I knew little of these basic problems when I first made snapshots in and around Yosemite. I was casually making a *visual diary*—recording where I had been and what I had seen—and becoming intimate with the spirit of wild places. Gradually my photographs began to mean something in themselves; they became records of experiences as well as of places. People responded to them, and my interest in the creative potential of photography grew apace. My piano suffered a serious rival. Family and friends would take me aside and say, "Do not give up your music; the camera cannot express the human soul." My soul was on trial during the years around 1930. I tried to keep both arts alive, but the camera won. I found that while the camera does not express the soul, perhaps a photograph can! My relatively incoherent and romantic philosophy was clarified and strengthened by meeting Paul Strand in Taos in 1930 and Alfred Stieglitz in New York in 1933. Stieglitz's doctrine of the equivalent as an explanation of creative photography opened the

world for me. In showing a photograph he implied, "Here is the equivalent of what I saw and felt." That is all I can ever say in words about my photographs; they must stand or fall, as objects of beauty and communication, on the silent evidence of their equivalence. Later my lifelong association with Beaumont and Nancy Newhall introduced me to the world of museums, exhibitions, and books. These people were among the few I knew who stood unflinchingly for quality and integrity in the arts. . . .

The years are jumbled and I cannot remember dates. But my recall of place and experience is precise. Seeing these photographs together brought back the exhilaration of my youth, striding the high places with a heavy camera, absorbing the beauty of both lichen and distant peak, the sound of wind and water, and the ever-present benediction of light. Nor can I forget the hundreds of friends and companions encountered through those years; it is hard to imagine what life would have been without them.

I am glad that the artist can move through the wilderness taking nothing away from its inexhaustible spirit and bringing his vision-modulated fragments to all who come to see.

"Nevada Fall, Rainbow, Yosemite National Park, 1946," from Examples: The Making of 40 Photographs (Boston: Little, Brown and Co., 1983) See Plate 16.

One spring day I packed my 8 × 10 view camera, two lenses, filters, and six double film holders, three filled with black-and-white film and the other three with color film. All this, together with the heavy tripod and lunch, weighed quite a lot. I feared my equipment might be drenched in the heavy mist on the Mist Trail near Vernal Fall at this time of year, so I used the longer alternative, the horse trail, dry and hot in the noon glare. The object of this excursion was to photograph the rainbow in front of Nevada Fall, which was booming full at this time of year and produced rolling clouds of mist that swirled down the canyon for more than half a mile. I arrived hours before the sun was in position for the rainbow to appear, and I scouted out an ideal spot to set up the tripod. I could anticipate the approximate

position of the rainbow by first noting where the shadow of my head might fall; the rainbow is about 44° from the axis of the sun.

It was apparent that I had several hours to wait, and I spent part of the time considering images produced by lenses of different focal length. Because of terrain and the complexity of the forest I was limited to one nearly ideal spot for my set-up. I had the time to engage in a protracted ballet with the tripod—forward, sideways, backward, and raising and lowering. All showed important changes in the relation of the branches of the nearby trees to the waterfall and the cliffs. I had a particularly hard time with the small tree in the extreme upper left corner of the image. There were many tips of branches to contend with that are not seen in the picture because of rigorous exclusion from the field of view. The tripod was set up in a jumble of rocks, and changing its position—even slightly—was arduous.

I missed on one small detail which ruffled; the right-hand tree of the two little cedars near the center of the image meets a branch from a nearby tree. I should have lowered the camera at least a foot to avoid this merger, but the front leg was already set at minimum length, and finding good footings for the other two—and for my own two as well—was a formidable task. In addition, the mist was blowing strenuously from the falls, and the camera had to be covered most of the time. The camera remained dry, but the focusing cloth and the photographer were being soaked! The sound and fury of the waterfall, the clean air and driving mist were unforgettable.

With the stately passage of time the rainbow appeared above the river and slowly rose to the position seen in the picture. . . .

"Base of Upper Yosemite Falls, Yosemite National Park, c. 1948," from Examples. See Plate 17.

One spring morning in 1948, Yosemite Fall was booming in flood, and I climbed to the base of the upper fall via Sunnyside Ledge and the granite slopes east of Yosemite Creek. I was carrying the $3^{1}/_{4} \times 4^{1}/_{4}$ Juwel with two Graflex magazines, each holding twelve sheets of Agfa Super-Pan Supreme film. It was a grand and relatively safe scramble. I could have moved

closer to the fall except for the gusts of driving spray that would have soaked my equipment. . . .

I was primarily interested in details of the falling water. I can clearly recall the continuous shattering sound of the waterfall and the constantly changing combinations of amorphous water masses punctuated with the meteor-like white arrows that held their shape from their thrusting formation at the top of the fall. At times the swirling mist would veil the more solid shapes of the falling water, then clear to reveal them in great depth.

I managed a composition of a lower section of the fall with small wind-blown conifers in the lower left corner. The branches of the right-hand side of the trees (facing the fall) are stripped—either by the driving force of water and wind or by winter ice falling from the cliffs above. I was aware of them as exciting accents to the more flowing shapes of the waterfall and to the strong vertical cliffs on the right. . . . When I had the basic composition determined, I waited for a considerable time for optimum conditions. There was a constant change of fast-moving shapes in the water, and gusts of windy spray would frequently force me to keep the camera covered with my focusing cloth. When the spray disappeared I would uncover the camera and await the precious moment. I made at least eight negatives before I felt I had succeeded, and then I made a few more to be sure. Clouds soon covered the sun, and with great expectations I returned to our home to develop the negatives.

"Clearing Winter Storm, Yosemite National Park, 1944," from Examples. See Plate 5.

Yosemite was home for many years for Virginia and me and our two children. We moved there in 1937 and took over management of the studio founded by Virginia's father, artist Harry C. Best, in 1901. Around 1947 we re-established our home in San Francisco as I had need for a professional studio; I could not legally conduct my professional work in a National Park.

While living in Yosemite I had great opportunity to follow the light and the storms, hoping always to encounter exciting situations. There were hundreds of spectacular weather events over the years, but the opportunities to photograph them were limited by the accidents of time and place, especially when working with 8 × 10 and 4 × 5 view cameras.

Weather, however spectacular to the eye, may present difficult conditions and compositions, especially when working with large cameras. Setting up the camera takes several minutes during which the first-promising aspects of light and cloud may disappear. I would sometimes wait hopefully for the scene that I could visualize as an exciting image. It was occasionally realized, but I have always been mindful of Edward Weston's remark, "If I wait for something here I may lose something better over there." I have found that keeping on the move is generally more rewarding. However, it is important to say that I photographed from this particular viewpoint in Yosemite many times over many years, with widely varying results.

Clearing Winter Storm came about on an early December day. The storm was first of heavy rain, which turned to snow and began to clear about noon. I drove to the place known as New Inspiration Point, which commands a marvelous vista of Yosemite Valley. I set up my 8 × 10 camera with my 12 $^1/_4$-inch Cooke Series XV lens and made the essential side and bottom compositional decisions. I first related the trees to the background mountains as well as to the possible camera positions allowed, and I waited for the clouds to form within the top areas of the image. Rapidly changing situations such as this one can create decision problems for the photographer. A moment of beauty is revealed and photographed; clouds, snow, or rain then obscure the scene, only to clear in a different way with another inviting prospect. There is no way to anticipate these occurrences.

At this location one cannot move more than a hundred feet or so to the left without reaching the edge of the almost perpendicular cliffs above the Merced River. Moving the same distance to the right would interpose a screen of trees or require an impractical position on the road. Moving forward would invite disaster on a very steep slope falling to the east. Moving the camera backward would bring the esplanade and the protective rock wall into the field of view. Hence, the camera position was determined, and the 12 $^1/_4$-inch Cooke lens was ideal for my visualized image. . . .

Although this photograph is often seen as an environmental statement, I do not recall that I ever intentionally made a photograph for environmentally

significant purposes. My photographs that are considered to relate to these issues are images conceived for their intrinsic aesthetic and emotional qualities, whatever these may be. To attempt to make a photograph like this one as an assignment for an environmental project, for example, would be stimulating but quite uncertain of result. I have been at this location countless times over many years, but only once did I encounter just such a combination of visual elements.

"Monolith, The Face of Half Dome, Yosemite National Park, 1927," from Examples.
See Plate 32.

At dawn, on a chill April 17, in 1927, my fiancée, Virginia, two friends (Charlie Michael and Arnold Williams), and I drove from our home to Happy Isles and began an eventful day of climbing and photographing. I had my 6 $^1/_2$ × 8 $^1/_2$ Korona View camera, with two lenses, two filters, a rather heavy wooden tripod, and twelve Wratten Panchromatic glass plates. Those were the days when I could climb thousands of feet with a heavy pack and think nothing of it; I was twenty-five and weighed about 125 pounds. Virginia and friends were fine climbers in those pre-roping times, and nothing daunted us.

We started up Le Conte Gully, under the north cliff of Grizzly Peak. It is quite steep and rough, with some rock faces requiring caution, and ends about 2500 feet above the valley floor. It is not a gully in the ordinary eroded-earth sense of the term, but a sharply pitched rocky cleft that possibly began as a fault or a fracture plane when the granite batholith of the Sierra was elevated. It was *cold* in the gulley; patches of snow and ice remained in the recesses of the rocks, and a chilly wind flowed over us from the high regions above. It was an exhilarating and promising morning, and we were cheered to meet the sun after a hard, cold climb in the frigid shadows. Ahead of us rose the long, continuously rising slope of the west shoulder of Half Dome—nearly 1500 feet more to climb.

Midway to the dome I photographed Mount Clark with a Dallmeyer Adon telephoto lens. I used a Wratten No. 29 (red) filter and I did the arithmetic accurately, involving the effective aperture of the Adon (a variable magnification lens) and the filter factor. The morning wind troubled the camera, and I waited for a lull that would permit a four-second exposure. I recall making three negatives of this; two were spoiled by the camera's movement during exposure.

I had made seven negatives all told by the time we reached the high area where the west shoulder meets the Dome, opposite the midway point of the 2000-foot cliff. This is called the "Diving Board," a tasteless name for such a wondrous place. It is a great shelf of granite, slightly overhanging, and nearly 4000 feet above its base. I made one photograph of Virginia standing on the brink of the rock edge, a tiny figure in a vast landscape. Score eight negatives. I tried a picture looking west into Yosemite Valley; it was ruined because the plate holder was not properly seated. Score nine negatives. I made a picture of the North Dome complex, but I overexposed it (I think I forgot to stop down the lens!). Score ten negatives. I had two plates left—and the most exciting subject was awaiting me!

I turned to the face of Half Dome. When we arrived about noon, it was in full shadow. In early mid-afternoon, while the sun was creeping upon it, I set up and composed my image. I was using a slightly wide-angle Tessar-formula lens of about 8 $^1/_2$ inch focal length. I did not have much space to move about in: an abyss was on my left, rocks and brush on my right. I made my first exposure with plate number eleven, using a Wratten No. 8 (K2) yellow filter, with an exposure factor of 2. As I replaced the slide I realized that the image would not carry the qualities I was aware of when I made the exposure. The majesty of the sculptural shape of the Dome in the solemn effect of half sunlight and half shadow would not, I thought, be properly conveyed using the K2 filter. I had only one plate left, and was aware of my poverty.

I saw the photograph as a brooding form, with deep shadows and a distant sharp white peak against a dark sky. The only way I could represent this adequately was to use my deep red Wratten No. 29 filter, hoping it would produce the effect I visualized. With the Wratten Panchromatic plate I was using, this filter reduced the exposure by a factor of 16. I attached the filter with great care, inserted the plate holder, set the shutter, and pulled the slide. I knew I had an exceptional possibility in my grasp. I checked

everything again, then pressed the shutter release for the 5-second exposure at f/22. Because the lens barely covered the plate, I was obliged to use a small lens stop, but fortunately there was no wind to disturb the camera during the long exposure. I most carefully inserted the slide and wrapped the plate holders in my focusing cloth for protection against the roughness of the long hike home. We left down the west shoulder of Half Dome into the Little Yosemite Valley and home via Nevada and Vernal Falls, arriving about dusk. I saw many gorgeous photographs on the way down but could do nothing about them, being out of plates.

This photograph represents my first conscious visualization; in my mind's eye I saw (with reasonable completeness) the final image as made with the red filter. I knew little of "controls." My exposures were based on experience, and I followed the usual basic information on lenses, filter factors, and development times. The red filter did what I expected it to do. I was fortunate that I had that twelfth plate left!

Over the years I became increasingly aware of the importance of visualization. The ability to anticipate—to see in the mind's eye, so to speak—the final print while viewing the subject makes it possible to apply the numerous controls of the craft in precise ways that contribute to achieving the desired result. . . . I can still recall the excitement of seeing the visualization "come true" when I removed the plate from the fixing bath for examination. The desired values were all there in their beautiful negative interpretation. This was one of the most exciting moments of my photographic career.

List of Plates

Acknowledgments

Many people helped in the preparation and production of this book:

Rod Dresser, business manager of The Ansel Adams Publishing Rights Trust, assisted in the preliminary selection of images. Jeff Nixon, of the Trust's staff, meticulously spotted and cropped every reproduction print as well as assisting in researching place names in the Sierra. Alan Ross and John Sexton, both former Photographic Assistants to Ansel Adams, made beautiful reproduction prints from Ansel's often challenging negatives. Antonis Ricos gently retouched reproduction prints to eliminate noticeable damage in the negatives. The Center for Creative Photography, particularly Marcia Tiede, assisted in the search for images. Dave Gardner has once again reproduced Ansel's photographs to the highest standards, a seemingly unique gift. Bruce Campbell designed a book that allows the photographs to speak eloquently to us with a directness and elegance that Ansel would have applauded. Janet Swan Bush and Terry Hackford and their colleagues at Little, Brown and Company have supported us with speed and wisdom based on many years of mutual effort. The Trustees of The Ansel Adams Publishing Rights Trust, more than anyone else, made this book possible with their vision of Ansel's artistic legacy. In particular, John Schaefer participated in the preliminary selection of the photographs, and Bill Turnage oversaw the selection of texts and defined the overall scope of the book. Finally, Virginia Adams gave unstintingly of her knowledge and experience in the preparation of this latest volume of her husband's photographs of Yosemite and the High Sierra, the glorious region in which they first met, were married, and spent many happy days living and exploring together.

Andrea G. Stillman

Sources for Portfolio Quotations

Ansel Adams: An Autobiography (Boston: New York Graphic Society, 1985), opposite Plates 57 and 64

Ansel Adams: Letters and Images 1916–1984 (Boston: New York Graphic Society, 1988), opposite Plate 42

Ansel Adams: Yosemite and the Range of Light (Boston: New York Graphic Society, 1979), opposite Plate 54

Examples: The Making of 40 Photographs (Boston: New York Graphic Society, 1983), opposite Plate 20

My Camera in Yosemite Valley (Boston: Houghton Mifflin, and Yosemite National Park: Virginia Adams, 1949), opposite Plates 27 and 34

"Portfolio III: Yosemite Valley," 1960, a limited edition portfolio of sixteen original photographs, opposite Plate 24

"Retrospect: Nineteen-Thirty-One," Sierra Club *Bulletin*, February 1932, opposite Plate 70

Sierra Nevada: The John Muir Trail (Berkeley: Archetype Press, 1938), opposite Plate 75

Standard Oil Picture Series, January 1946, opposite Plates 17 and 30

Yosemite and the High Sierra, photographs by Ansel Adams and text by John Muir (Boston: Houghton Mifflin, 1948), opposite Plate 11

Designed by Bruce Campbell

Printed and bound by Amilcare Pizzi, Italy

Typeset in Centaur by The Sarabande Press

Paper is Gardagloss coated